# LANDSCAPES
## *of* Ireland

### MICHAEL DIGGIN

Gill & Macmillan

*Gill & Macmillan Ltd*
*Hume Avenue, Park West, Dublin 12*
*with associated companies throughout the world*
*www.gillmacmillan.ie*
*Photographs © Michael Diggin 2001*
*Text © Gill & Macmillan 2001*
*ISBN 13: 978 07171 3199 0*
*ISBN 10: 0 7171 3199 8*
*Design and Repro by Ultragraphics, Dublin*
*Maps by EastWest Mapping*
*Printed in Spain*

*7 6 5 4 3*

# Introduction

Ireland is shaped like a saucer, with mountains around the coast and a flat plain in the centre. This image is one of the country's most tenacious clichés. And like many clichés, it is substantially true.

Most of the high hills of Ireland are indeed around the coast. Wicklow, west Cork and Kerry, Clare, Connemara, Donegal, Antrim, and the Mournes in Co. Down are all either on, or very close to the coastline. In the words of Percy French's famous song, he longs to be 'where the Mountains of Mourne sweep down to the sea', which they do in very dramatic style around Newcastle, Co. Down.

Not that the interior is as flat as that mythical saucer. There are uplands in many inland counties: the Slieve Blooms in Offaly; the Galtees and Knockmealdowns in north Cork and south Tipperary; the Sperrins in Tyrone. But still, the saucer image is basically fair. Most of the inland parts of Ireland are flat.

There is, however, flat and flat. The river valleys of the south-east through which the Barrow, Nore, Suir and Slaney flow, are among the most lushly cultivated parts of the country. But in many cases, there is rising ground not far away and the valleys are literally the rich lowlands between the hills. The Blackwater valley in north Co. Cork – land coveted by native and newcomer alike since the dawn of time – flows past ranges of hills on both sides for most of its journey to the sea at Youghal. Even the Nore, flowing through that quintessential inland county, Kilkenny, has to bend its way around the eminence of Brandon Hill before joining the Barrow just above New Ross.

The greatest of Irish rivers is the Shannon and it flows through countryside that really is low-lying. No hills here: some drumlins at the northern end, perhaps, but after that it forms a flood plain. The great river works its way south from Co. Cavan, through a series of lakes, picking up tributaries right and left and being joined by two canals from Dublin, until it finally opens into the great estuary between counties Clare and Kerry and flows into the Atlantic. In winter, it regularly floods areas of east Galway and west Offaly. In all, the Shannon and its tributaries drain more than twenty per cent of the entire island.

Which brings us back to the coast and the mountains. Nine of the ten highest mountains in Ireland are within thirty kilometres of the sea. And that is the key to the image that comes first to mind when we think of the landscape of Ireland: the meeting of the mountains and the sea. The magnificence of Slea Head at the end of the Dingle Peninsula in Co. Kerry; the Twelve Bens in Galway; Croagh Patrick in Mayo; Bloody Foreland or Slieve League in Donegal; the Mountains of Mourne. It is this conjunction of mountain and ocean that sticks in the imagination as the defining image of Ireland.

*Although not a combination unique to Ireland, the mountains and the sea join here in a manner different to other places. For instance, it is hardly necessary to elaborate on the contrast between Ireland and, say, Greece. The wet winters, the mild temperatures, the amazingly long summer twilights, the poor land along many parts of the western seaboard, the heathers and gorses and fuchsias and golden rod, and the sheer tumult of the Atlantic Ocean at your feet: all add to a mélange that is unique. And for some – not just Irish people, either – this is the most beloved landscape in the world.*

*This wonderful collection of pictures captures the variety of the Irish landscape, sometimes dramatic, sometimes subtle. Michael Diggin's camera takes us to every county in Ireland. These images of the multiple landscapes of Ireland will fix in the memory those moments when the light suddenly changes, when clouds in off the Atlantic scud across the sun, when a shadow dances on a lake.*

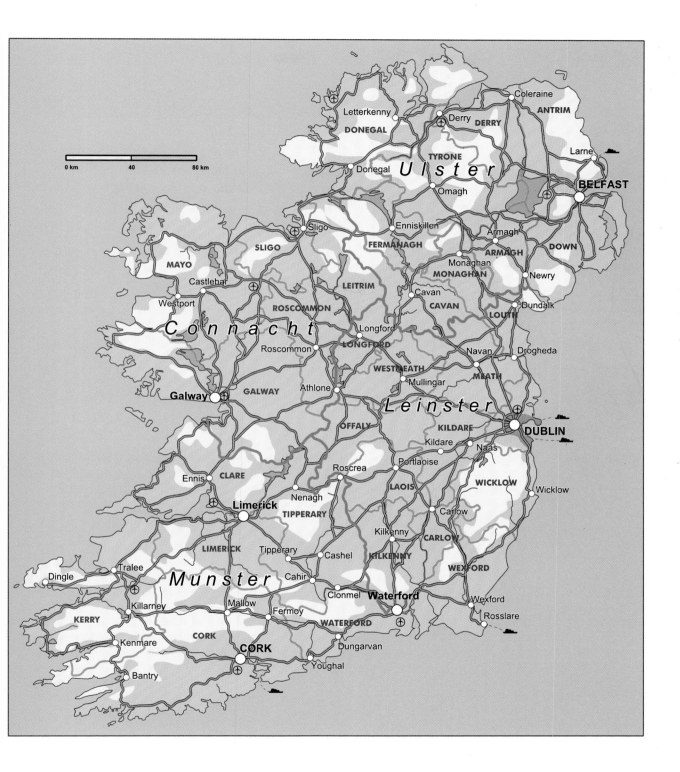

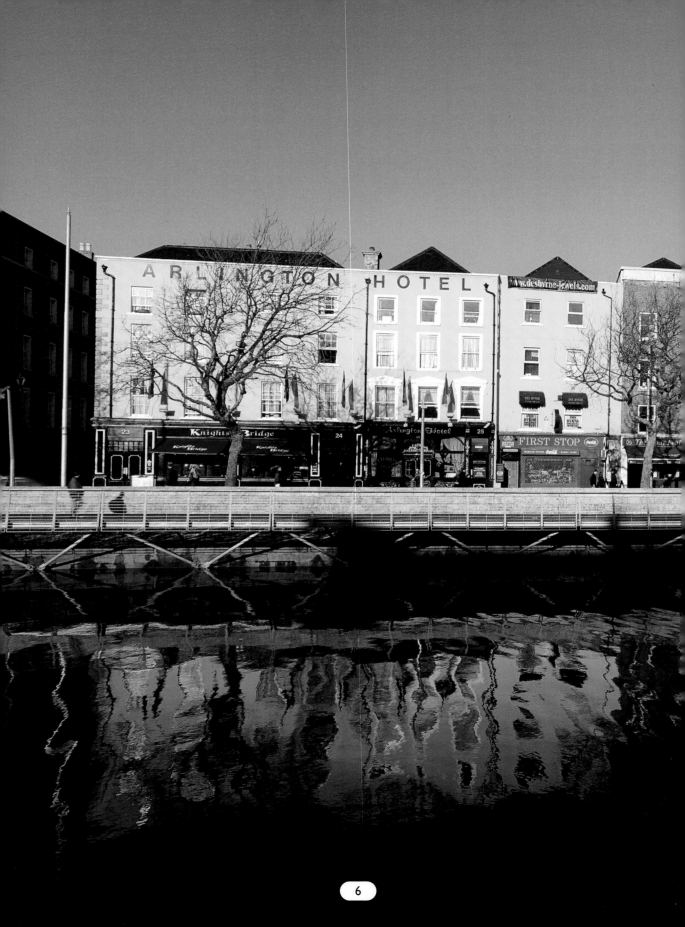

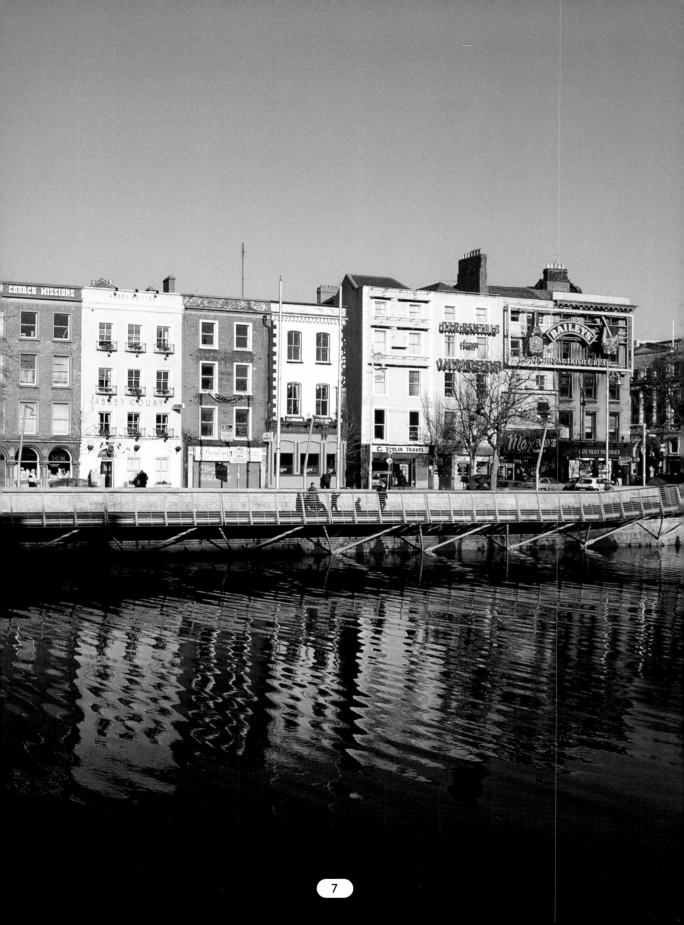

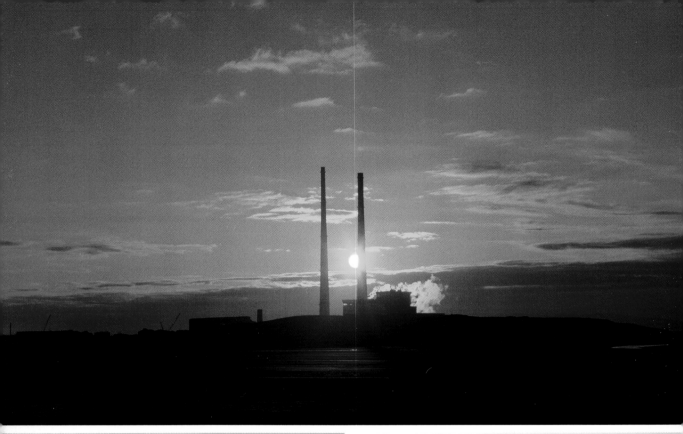

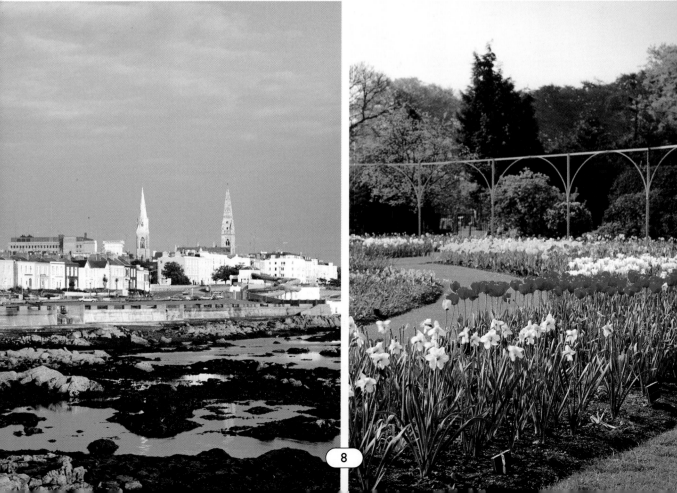

*Images of Dublin. The River Liffey showing the boardwalk (preceding pages). The distinctive twin chimneys of the Poolbeg Power Station at Ringsend (above left) seen at first light across Sandymount Strand. Dun Laoghaire (far left) seen from the shore at Sandycove. The National Botanic Gardens in Glasnevin (left) in full flower. Portobello Harbour (above) with the old harbour hotel built in the heyday of the Grand Canal.*

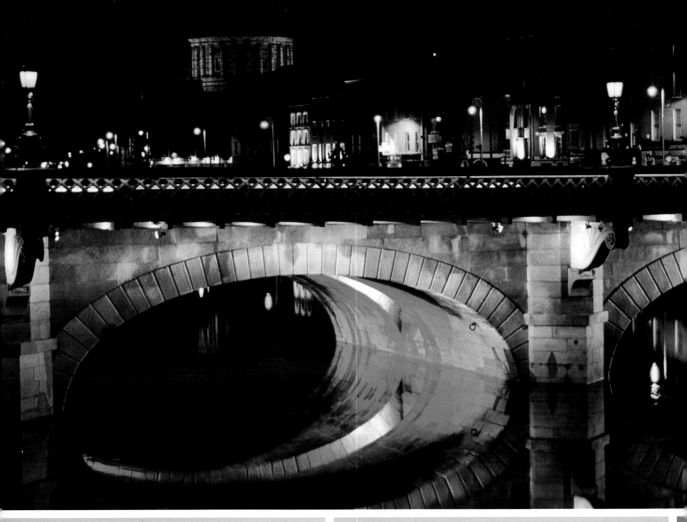

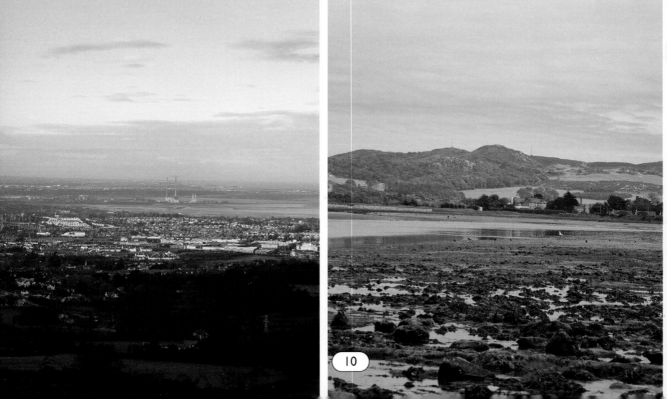

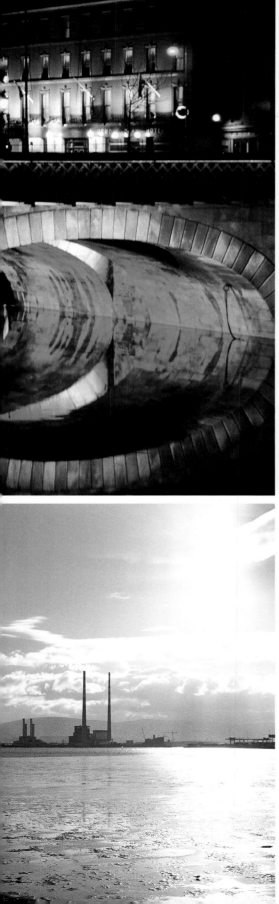

*Capel Street Bridge by night (above left) with the great drum of the Four Courts in the background. The view across the southern suburbs and the inner bay from Killakee in the Dublin Mountains (far left). Howth Head (centre left) at the northern end of the bay, with its famous rhododendron in full bloom. Low tide at the North Bull Island (left). A tranquil scene in St Stephen's Green (above).*

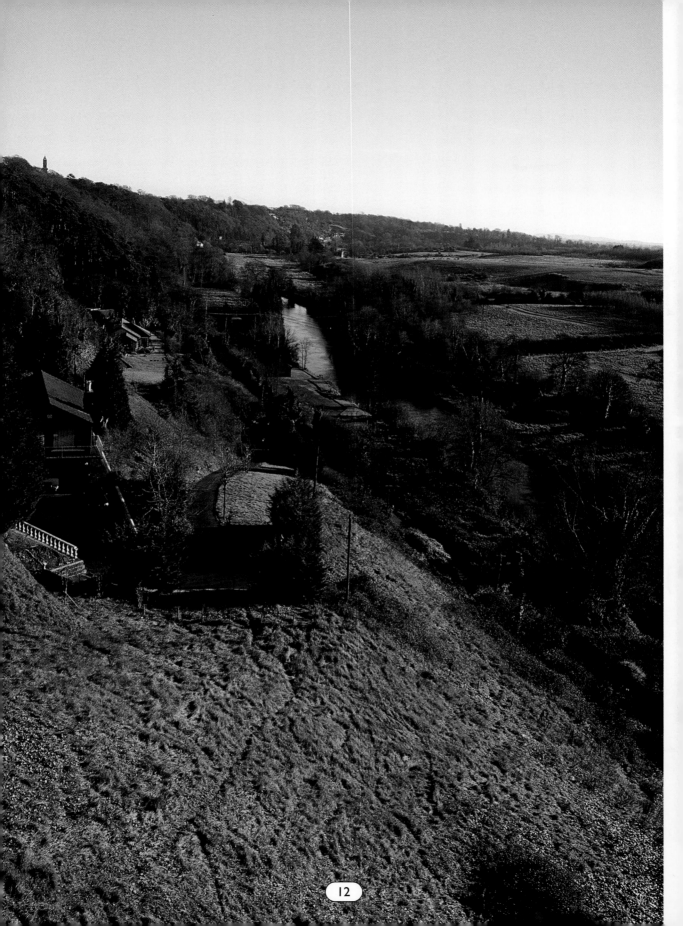

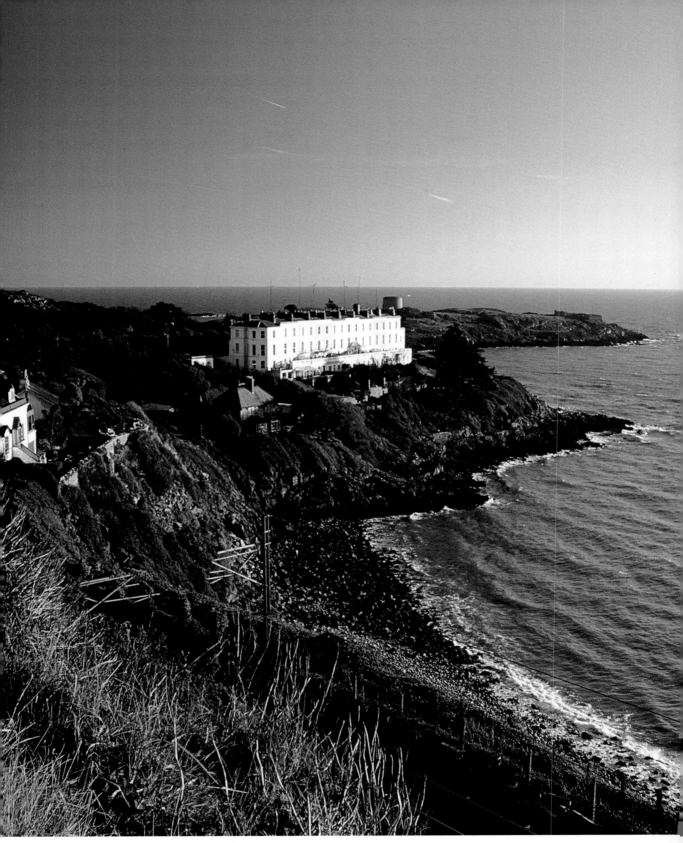

*A view of the River Liffey as it passes through the Strawberry Beds at Lucan, Co. Dublin (opposite).*
*Killiney Bay in south Co. Dublin (above).*

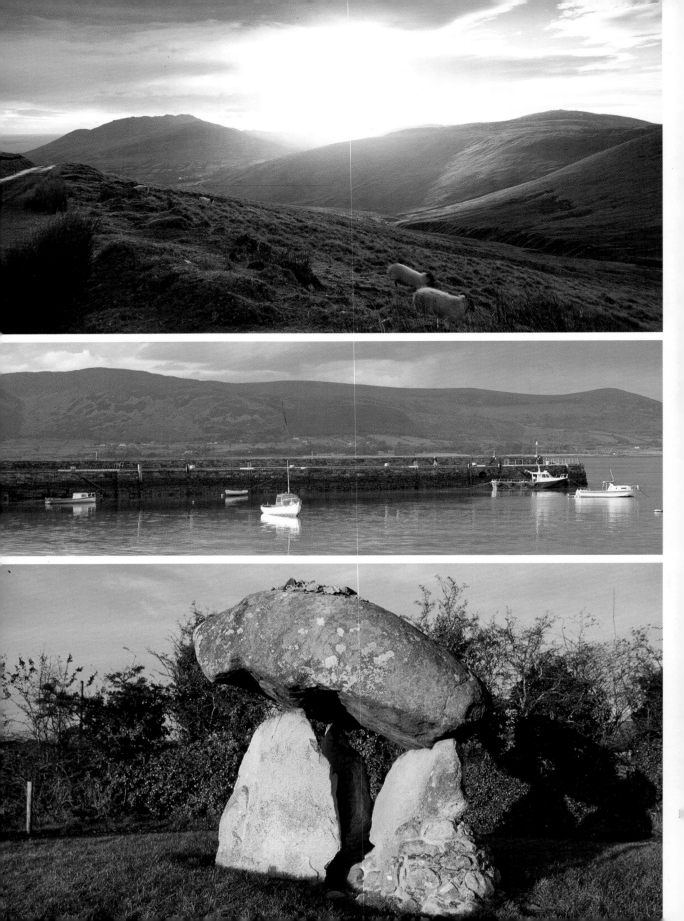

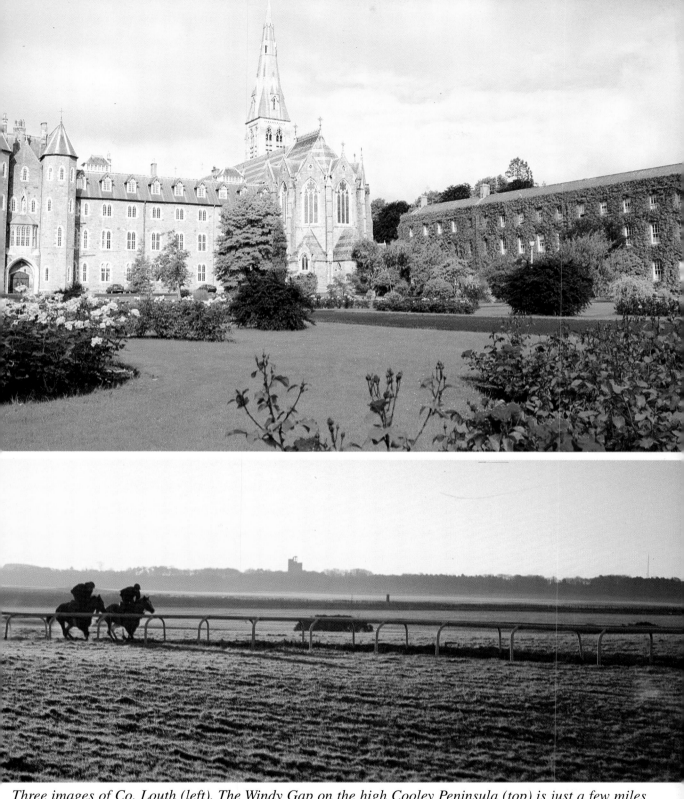

*Three images of Co. Louth (left). The Windy Gap on the high Cooley Peninsula (top) is just a few miles from the placid waters of Carlingford Harbour (centre). The Proleek Dolmen near Dundalk (below) is one of the most impressive ancient monuments in this part of the country.*
*Co. Kildare: The grounds of Maynooth College (top), and horses being exercised at dawn on the flat plain of the Curragh (above).*

*Co. Meath is drained by the River Boyne (opposite, top left and below). It is a county of fertile farmland, ideal for dairy farming, but it also contains many Neolithic burial sites and other ancient monuments. Slieve na Caillighe (above) is one such, while the Hill of Tara (opposite above right) was the seat of the so-called High Kings of Ireland. The title of High King was largely honorific, but the site had a religious as well as a royal significance from ancient times.*

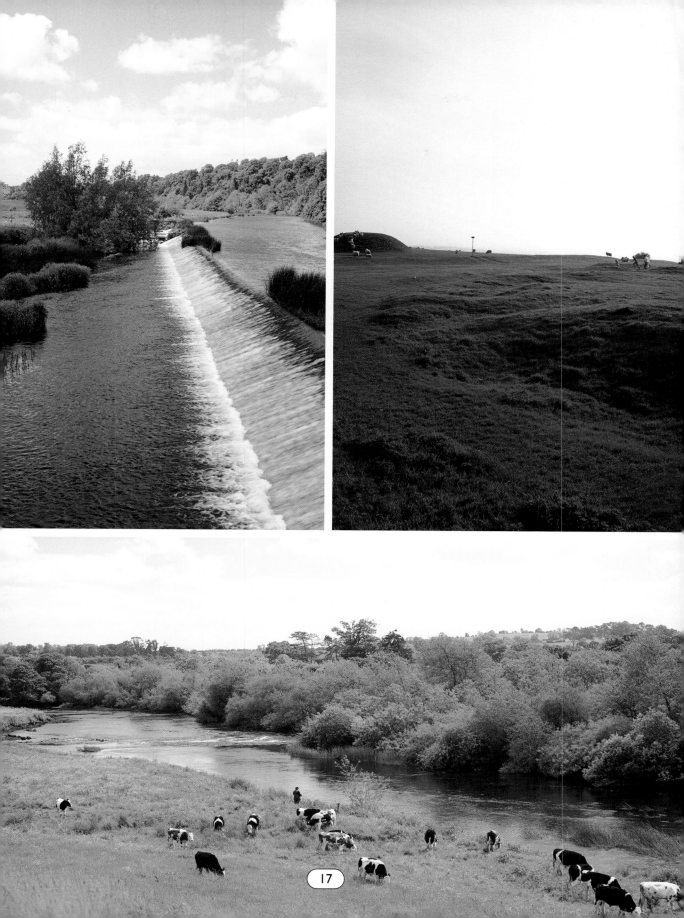

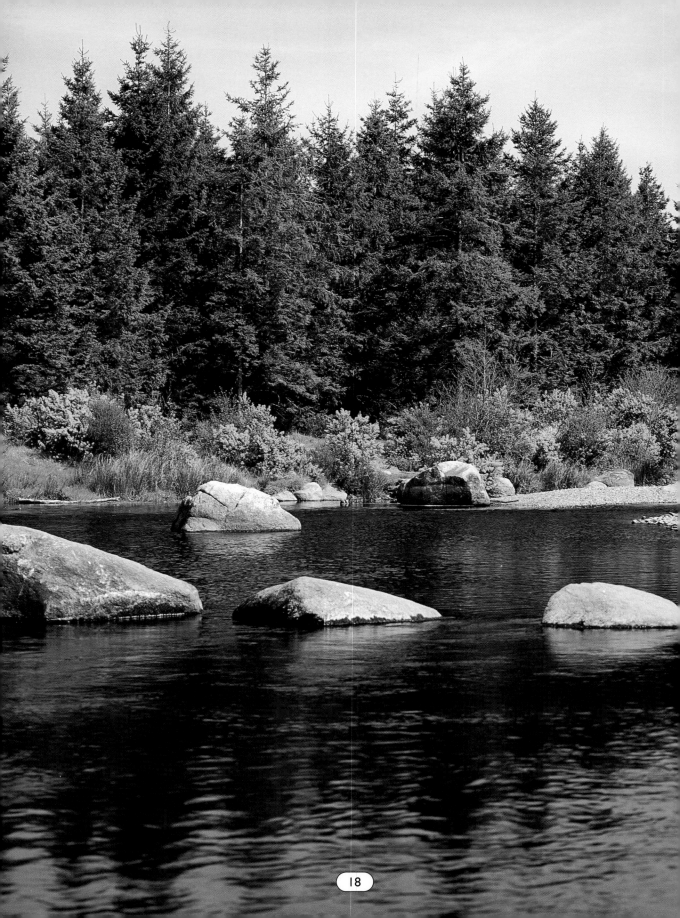

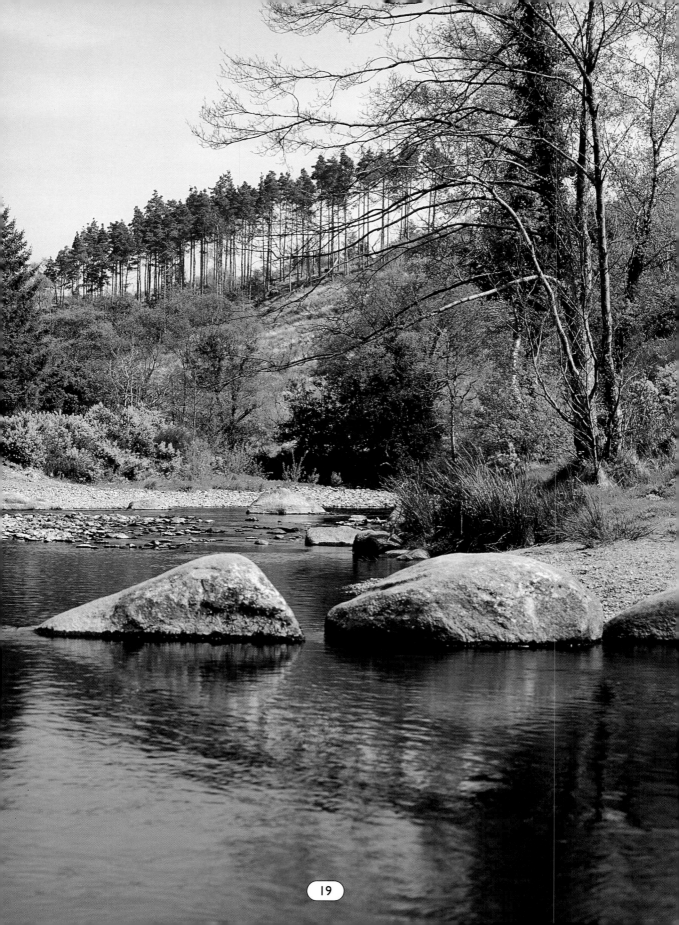

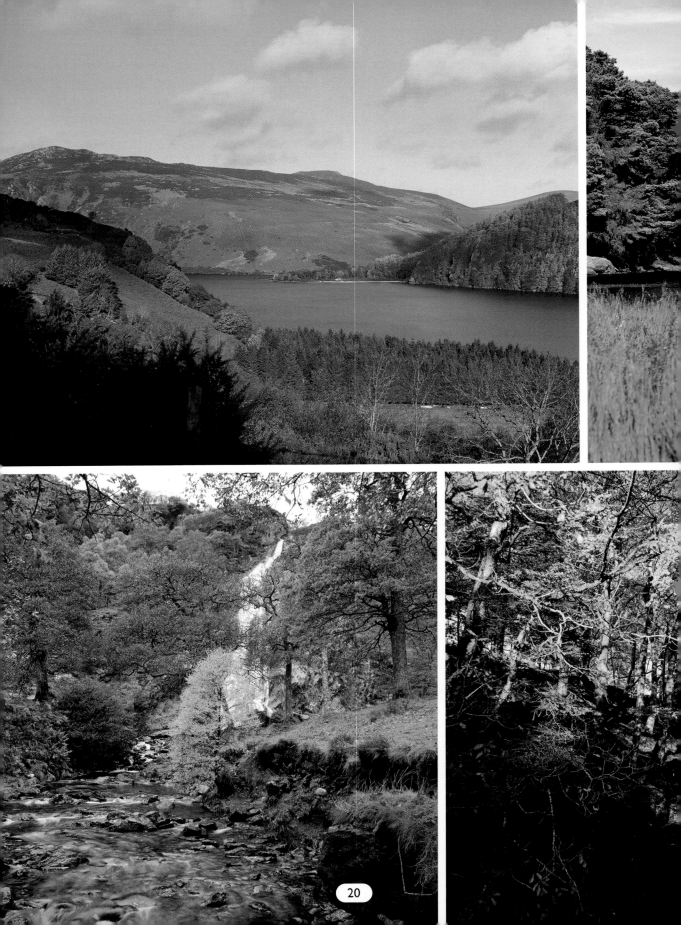

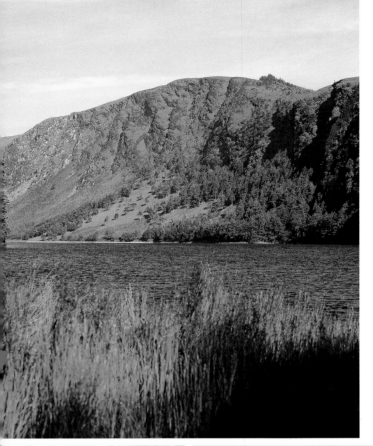

Stones form a bridge across the River Avondale at Trooperstown Wood near Laragh, Co. Wicklow (preceding pages). Co. Wicklow is a contrasting landscape of coast, upland lakes and high mountains. Lough Dan near Roundwood (far left) and Glendalough (left) – which means simply the valley of the two lakes – are popular beauty spots. The Powerscourt Waterfall (below far left) is the highest in Ireland. The contrast between it and that in the autumnal woodland (below centre) is fairly obvious. Below is a fine view of the distinctive Sugar Loaf Mountain.

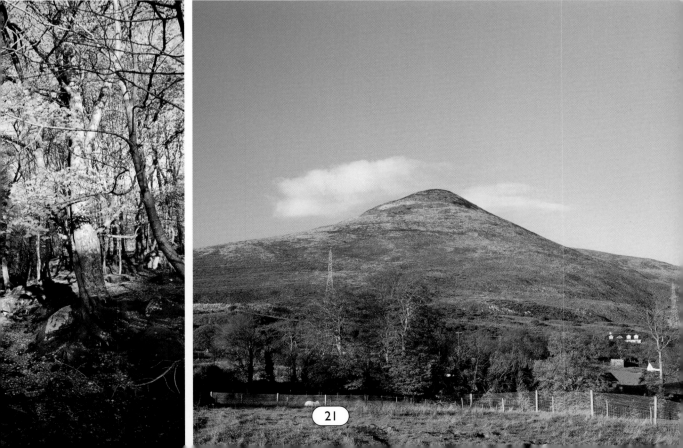

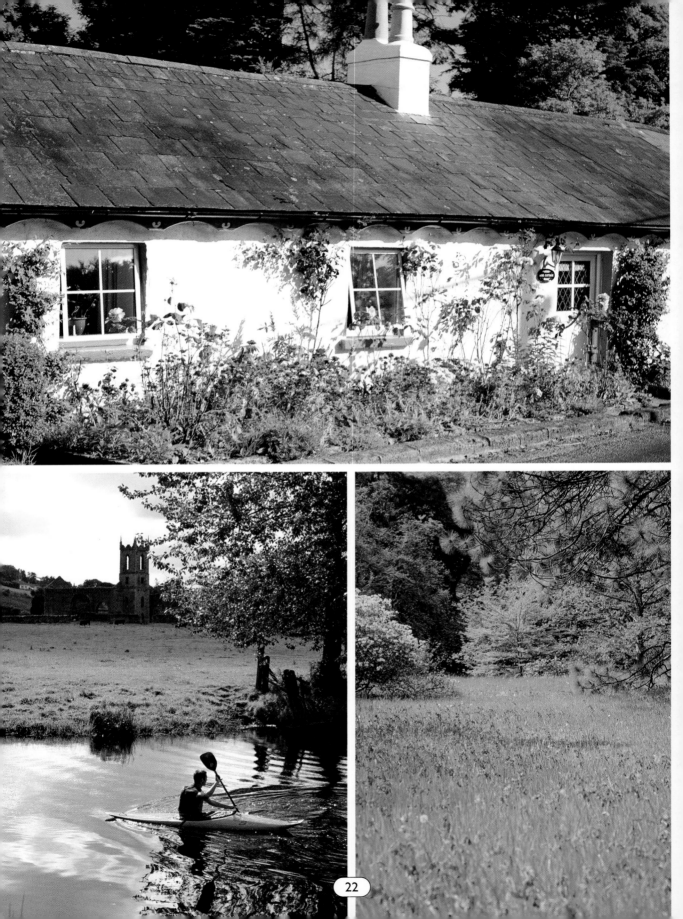

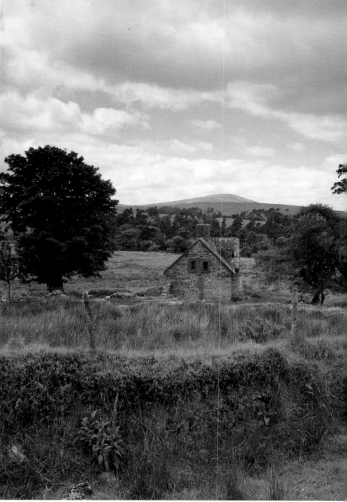

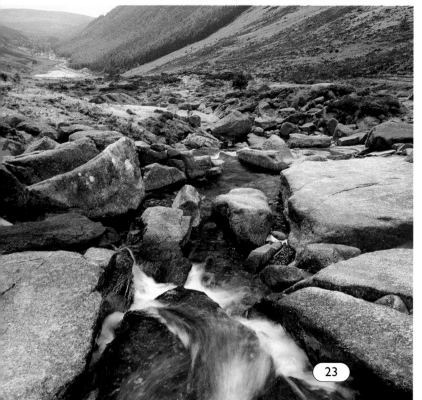

Co. Wicklow cottage at Annamoe (opposite above). A tranquil scene on the River Slaney near Baltinglass in west Wicklow (opposite far left). Mount Usher Gardens (opposite bottom right) is one of the most attractive gardens in Ireland, featuring a fabulous array of exotic plants and flowers. The elegance of the entrance to the Powerscourt demesne (above left) contrasts with the wilder country near the Sally Gap (above right) and that at the Wicklow Gap (left).

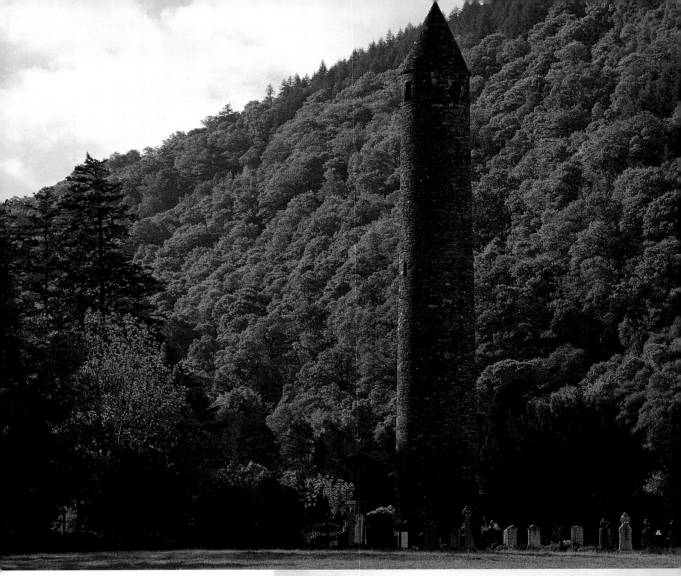

*The Round Tower at Glendalough
(above) is one of the most
impressive in Ireland.
The tranquil harbour at
Greystones, Co. Wicklow (right).*

*The end of the rainbow is where
the River Shannon rises, the
'Shannon Pot' in Co. Cavan
(opposite).*

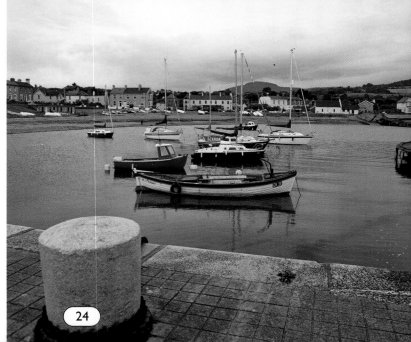

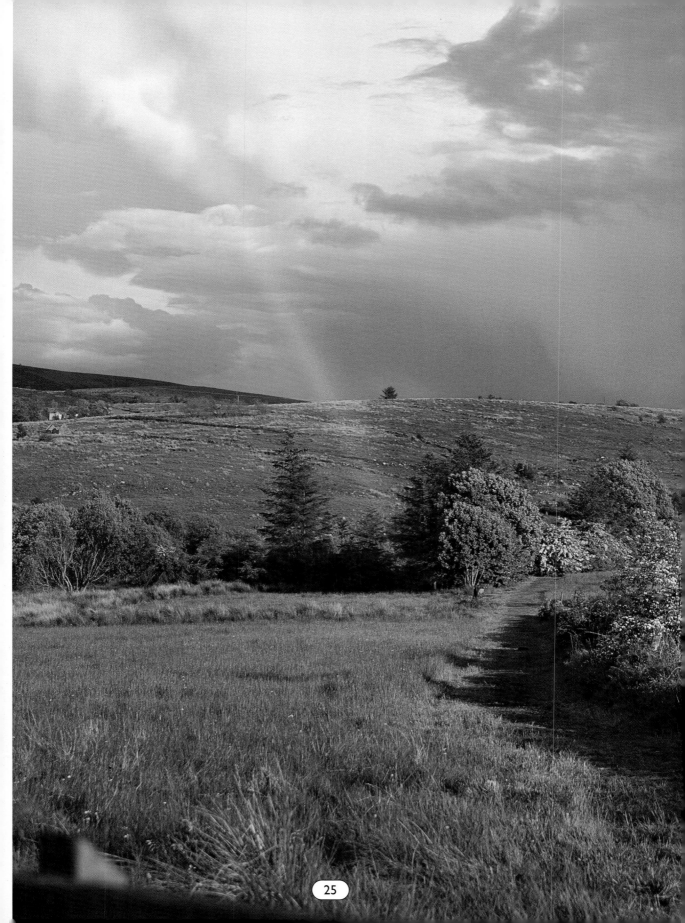

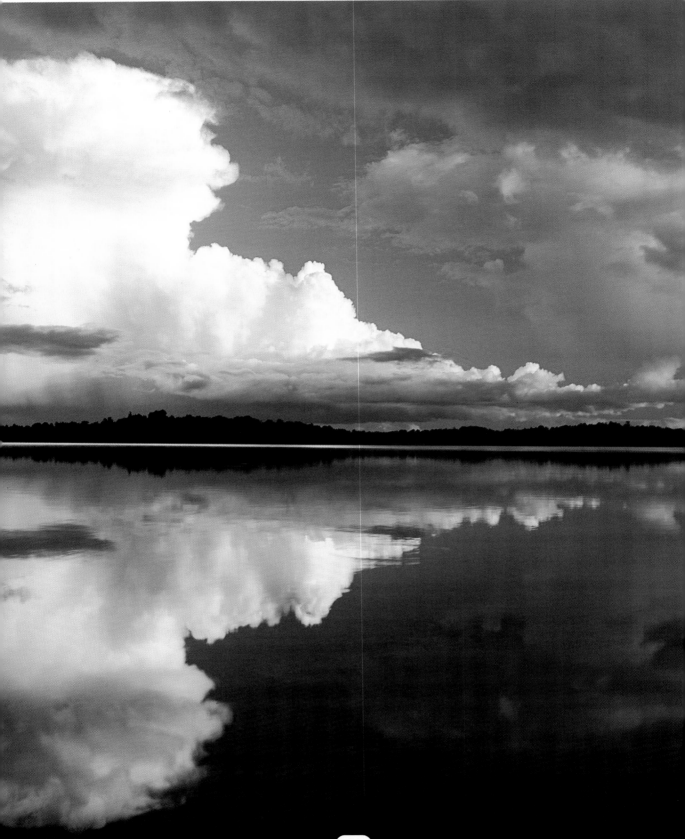

*Brackley Lake near Bawnboy in Co. Cavan, a county honeycombed with lakes and rivers.*

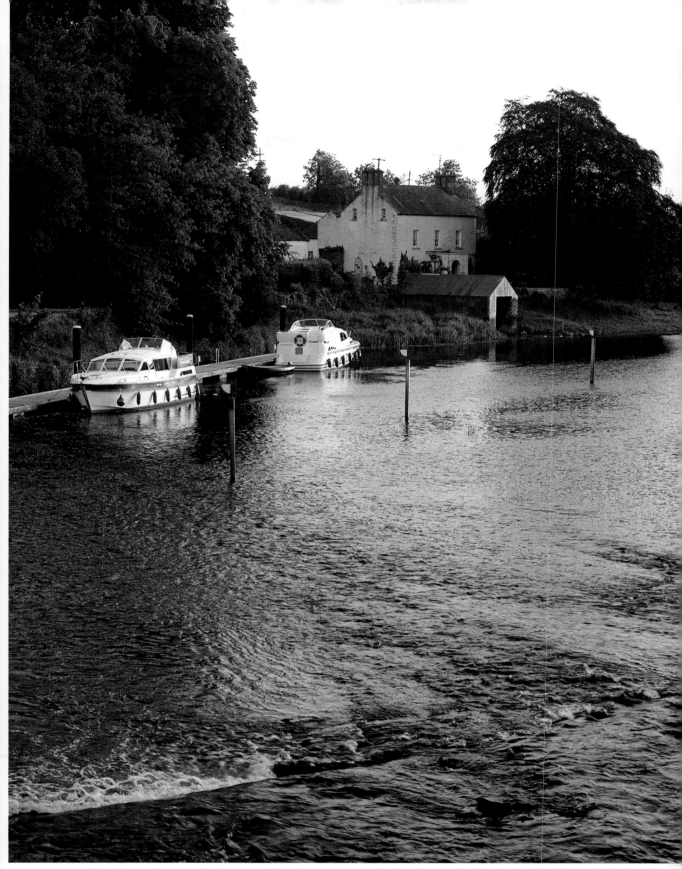

*The River Erne at Belturbet, Co. Cavan, near the border with Co. Fermanagh.*

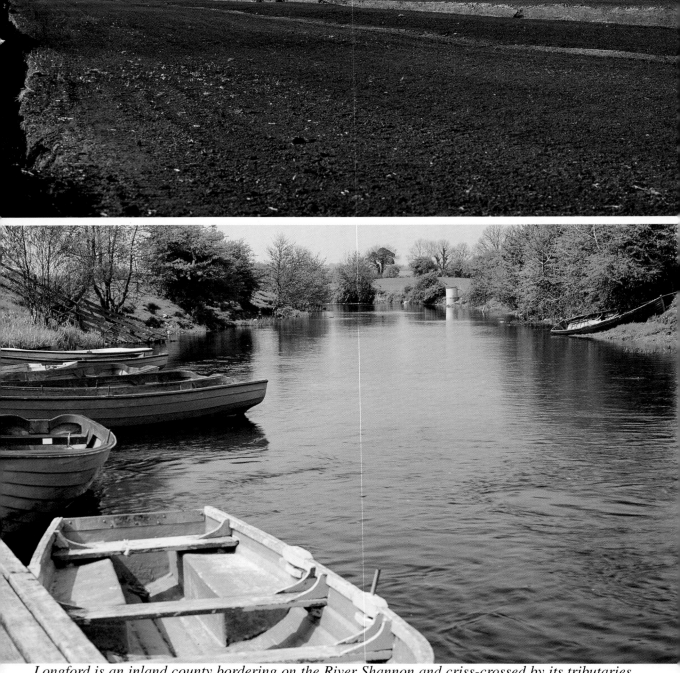

*Longford is an inland county bordering on the River Shannon and criss-crossed by its tributaries (above). Like every midland county, it has many bogs (top) which are harvested so that the peat can be compressed and sold as domestic fuel. On the far side of the Shannon, Co. Roscommon is in another province – Connacht – but is part of the same physical region. The ruins at Boyle Abbey (detail, opposite top left) are among the most impressive monastic ruins in the country. Rooskey (opposite top right) is a popular stopping place on the Shannon while Lough Bofin (right) is one of the many lakes on the Shannon system. Of these, none is more spectacular than Lough Key (following two pages) with its forest park.*

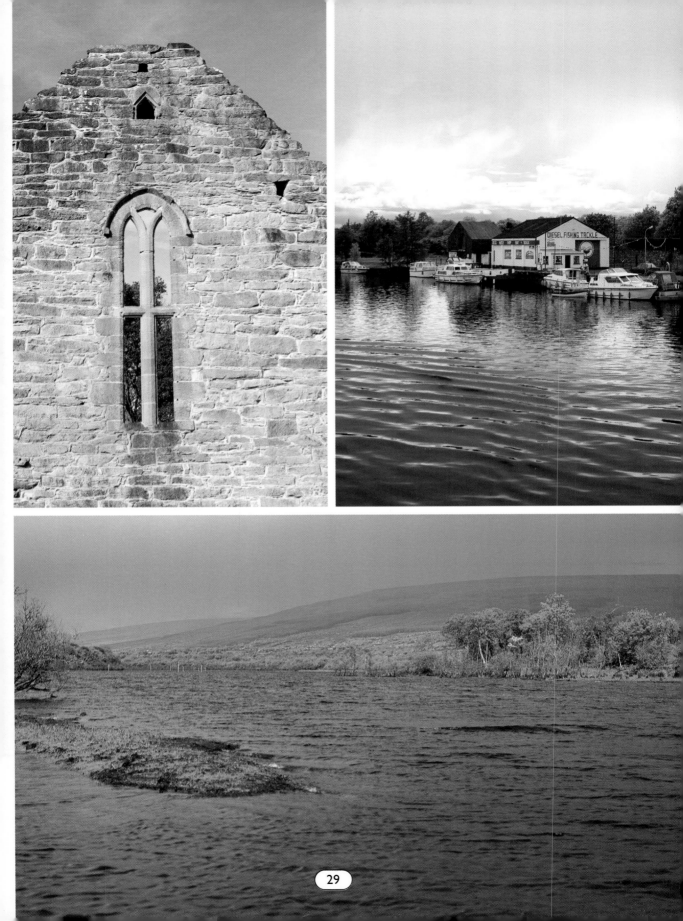

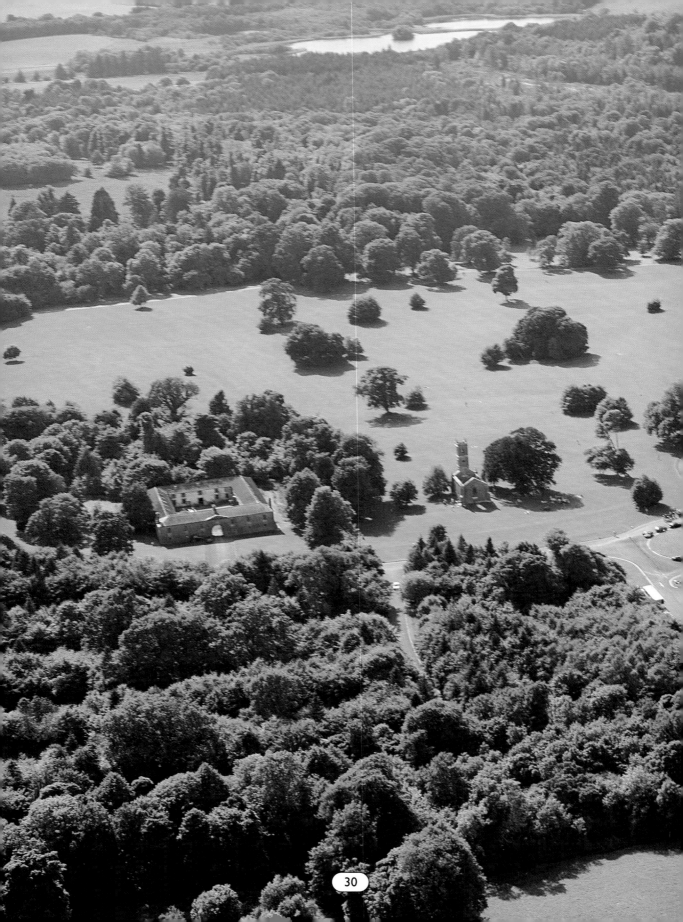

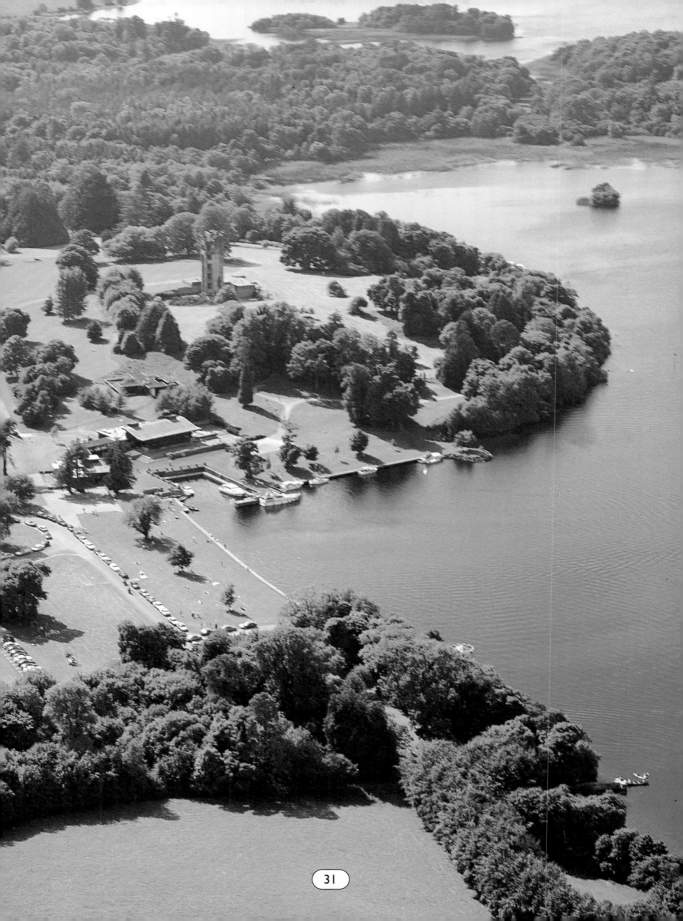

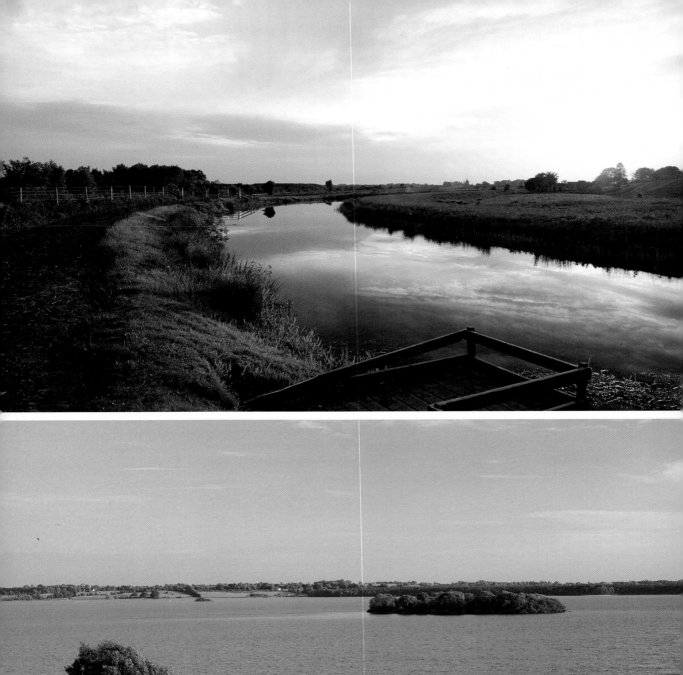

*Co. Westmeath in the centre of Ireland has the familiar midland pattern of good farmland and waterways. The Royal Canal near Mullingar (top) is one of the two canals that connected Dublin to the River Shannon. Lough Ennell (above) is one of the most beautiful lakes in the midlands. The Shannon itself, seen (opposite) crashing over the weir at Athlone, dominates the whole region.*

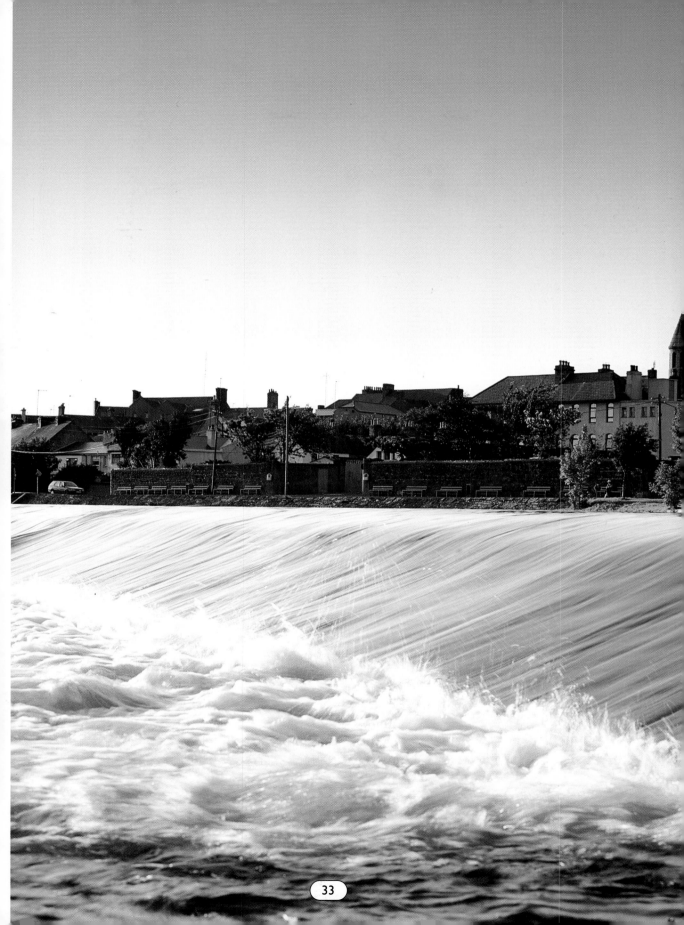

*The Shannon below Athlone in Co. Offaly (right). At a bend in the river, the great monastery of Clonmacnoise (below left and right) stood on the eastern bank for nearly a thousand years. It was a religious and scholarly centre of international importance until its final destruction in the sixteenth century. Even now its ruins have a peculiar grandeur.*

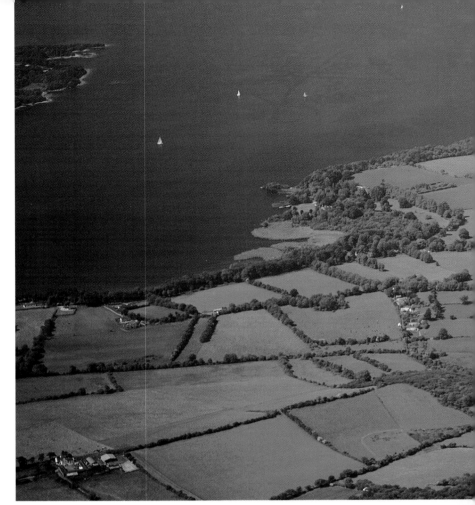

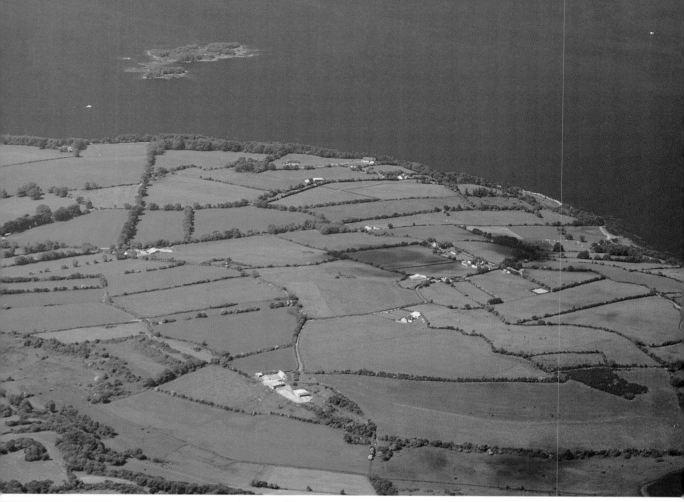
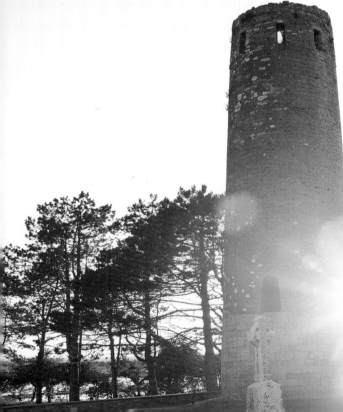

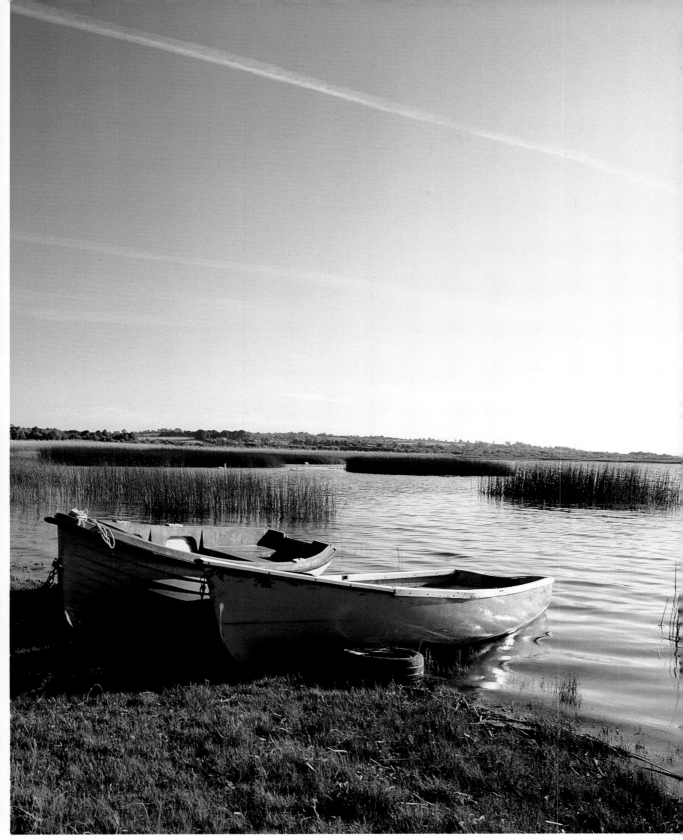

*The ruins of the castle on the Rock of Dunamase in Co. Laois (top left) contrast with the cheerful cottage window below. The placid, reedy shore of Lough Derravaragh in Co. Westmeath (above) is a familiar midland scene.*

*Bog cotton*

*Bagenalstown, Co. Carlow (top) is one of the prettiest towns on the River Barrow. There were many mills built along the river, although none of them is still in production and many are in a ruinous state (above). The Barrow is the second longest river in Ireland. Being in the south-east of the country, it is closer to Britain and France and was therefore a more popular and accessible invasion route than the Shannon further west.*

*The old tower house at Kilcash was the home of the cadet branch of the Butler family whose main branch – the earls of Ormond based in Kilkenny – were the principal family of this entire region. After its destruction, an anonymous poet wrote a lament for it which is one of the most famous pieces of verse in the Irish language and was memorably translated into English by Frank O'Connor (with a little help from Yeats). Less grand, but equally impressive in its own way, is a thatched cottage near Callan, Co. Kilkenny (opposite top left). Graiguenamanagh (opposite top right) is an historic ecclesiastical centre as well as a popular stopping place for leisure craft on the Barrow. The river with which Co. Kilkenny is most associated, however, is the Nore, seen (below right) at Thomastown. The Nore is a tributary of the Barrow which it joins just above New Ross, Co. Wexford. Following pages: Two contrasting images of inland tranquillity.*

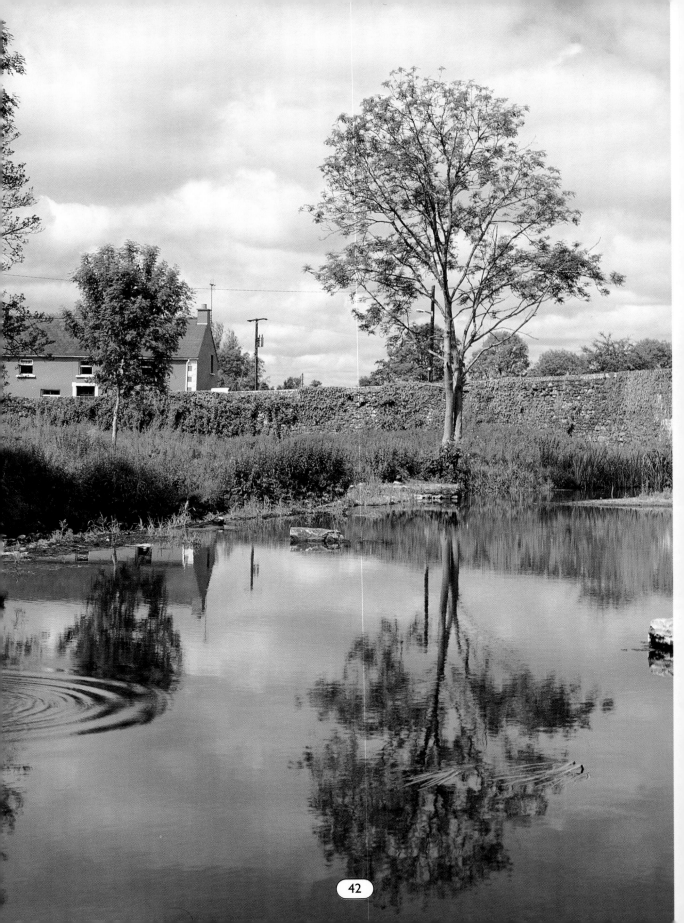

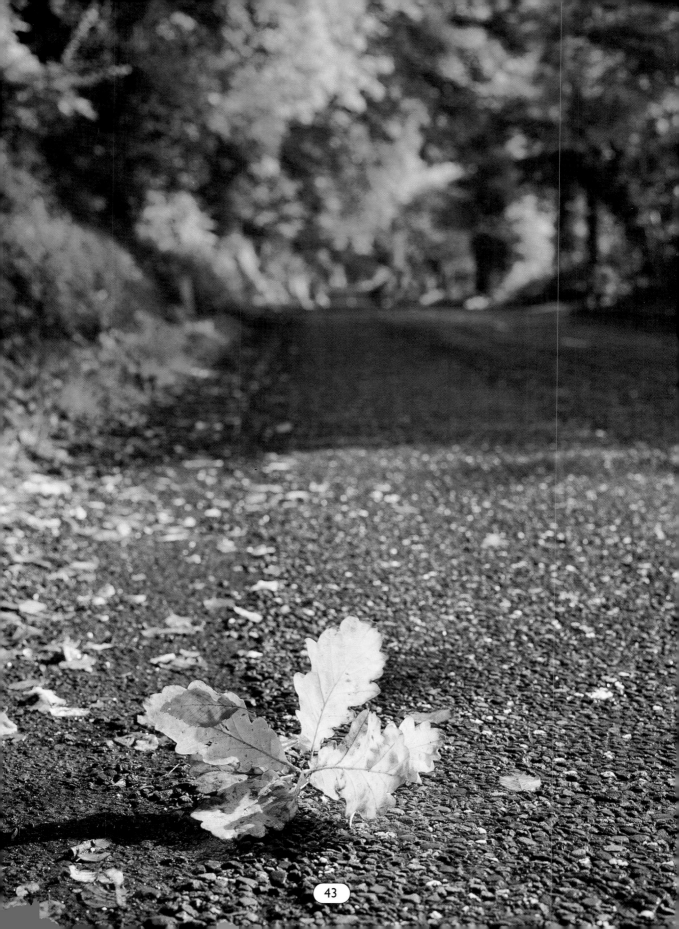

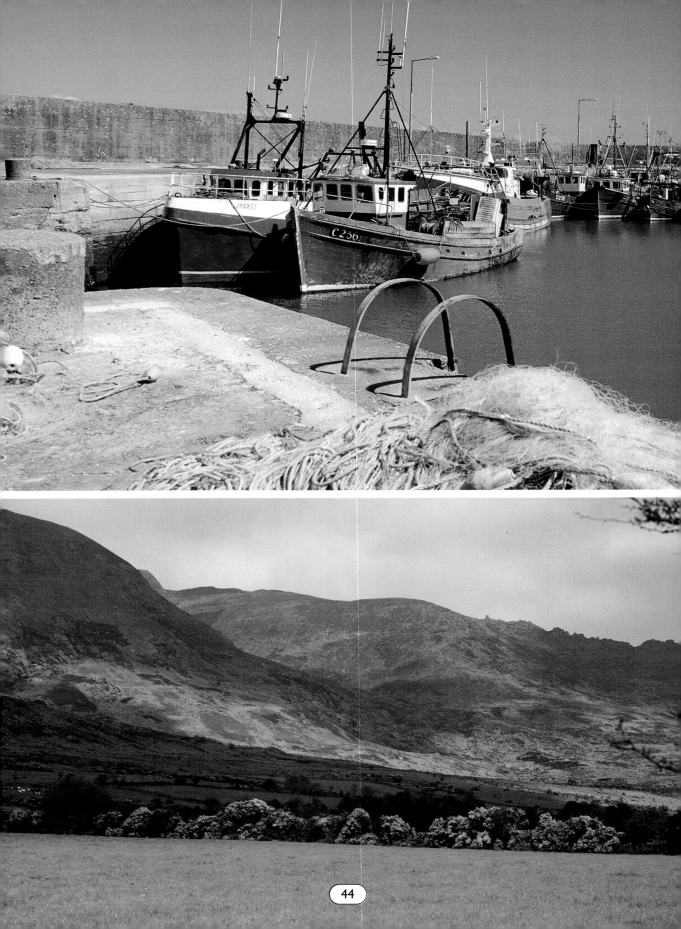

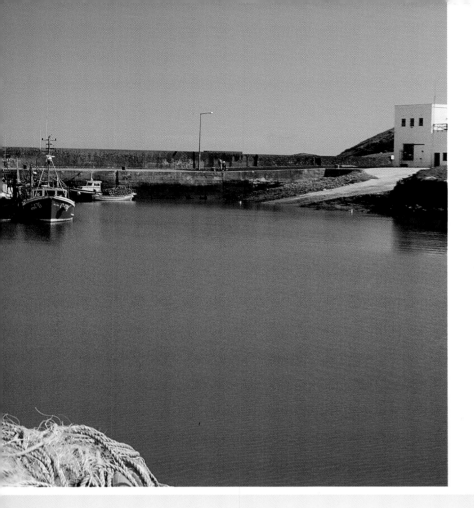

*The landscape of Co. Waterford is a contrast of coastal towns and villages (left) and the valley of the River Suir (below) running in a fertile strip beneath the Comeragh Mountains (below left).*

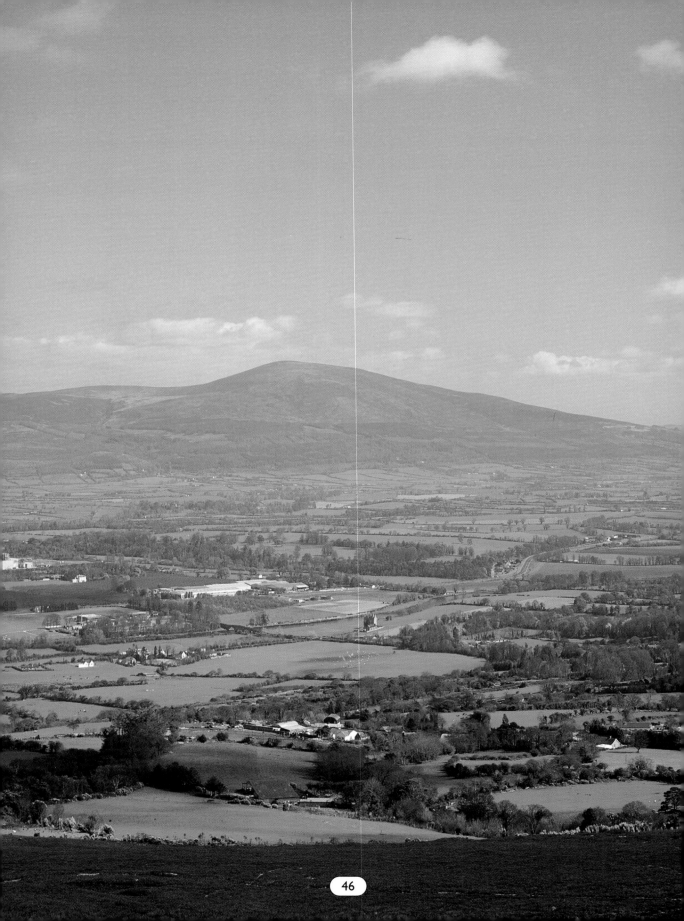

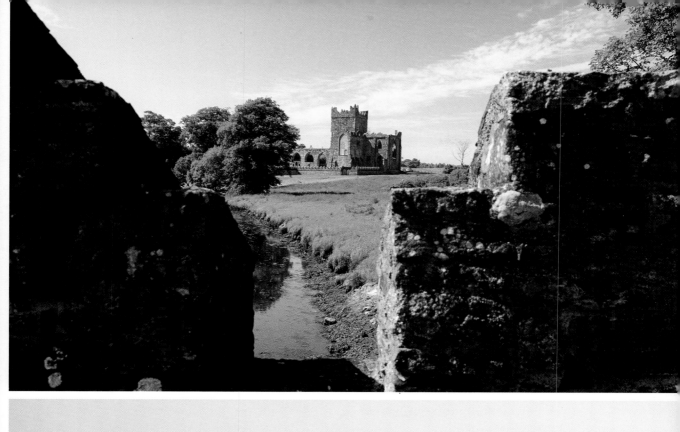

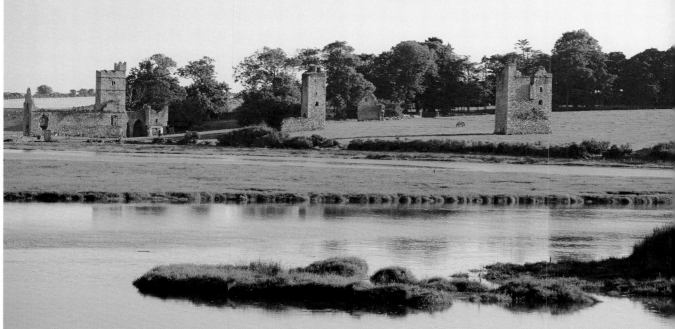

*Another view of the Suir Valley (left), looking north towards Slievenamon in south Co. Tipperary. This is some of the finest farmland in Ireland. Tintern Abbey (top) in south Co. Wexford was a sister house of the Welsh abbey of the same name, immortalised in Wordsworth's poem. The remains of a medieval settlement at nearby Wellington Bridge (above).*

*Following pages: The quay front at New Ross, Co. Wexford. The River Barrow is navigable for ocean-going craft up to this point. The lighthouse at Hook Head (right) on the very outer reaches of the Barrow estuary.*

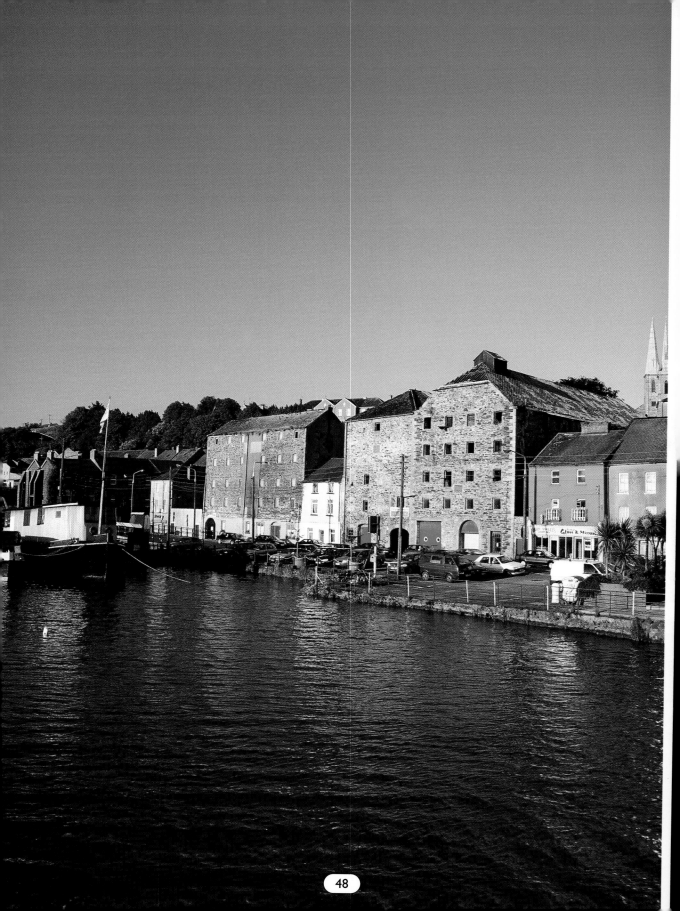

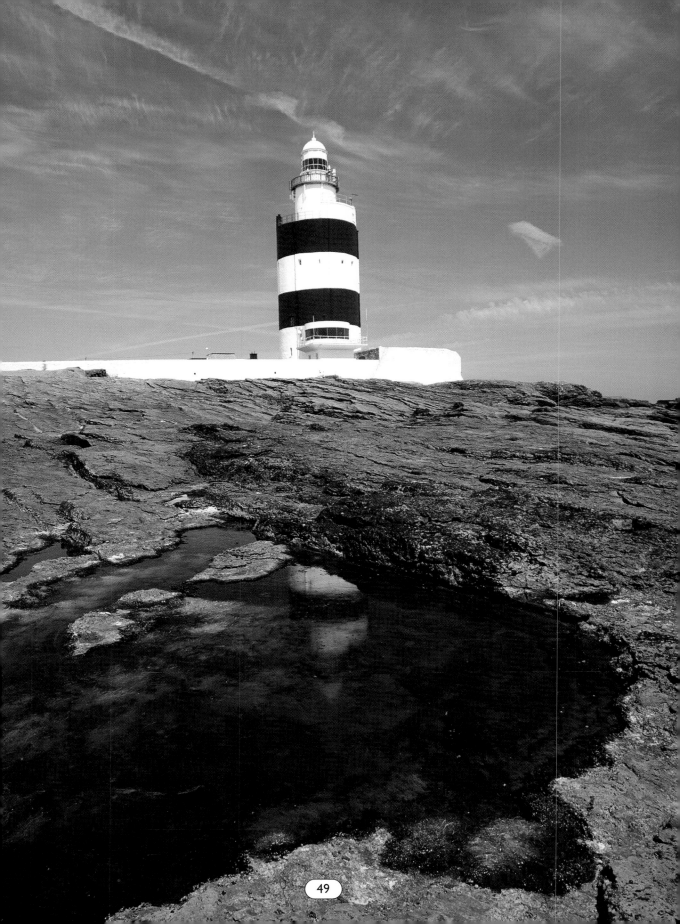

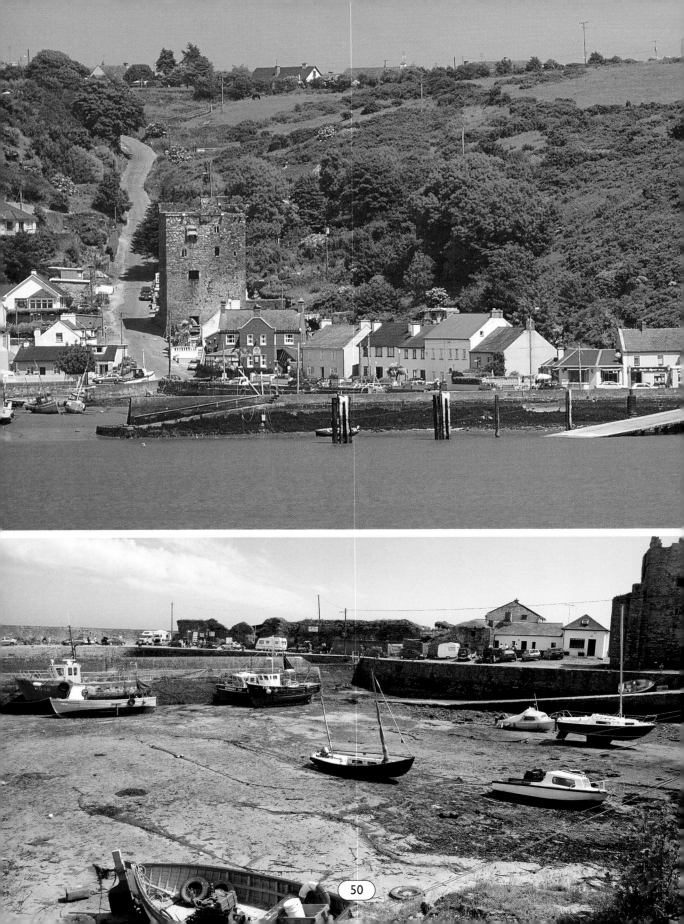

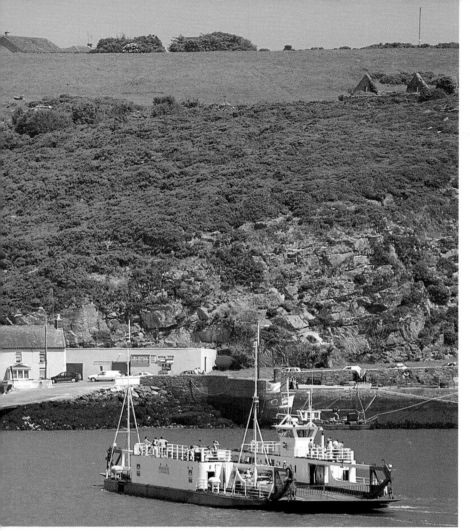

*Ballyhack, Co. Wexford (left) showing the car ferry coming across from Passage East, Co. Waterford on the west bank of the Barrow. Beached boats in Slade, south Co. Wexford (below left). The Maritime Museum at Kilmore Quay (below).*

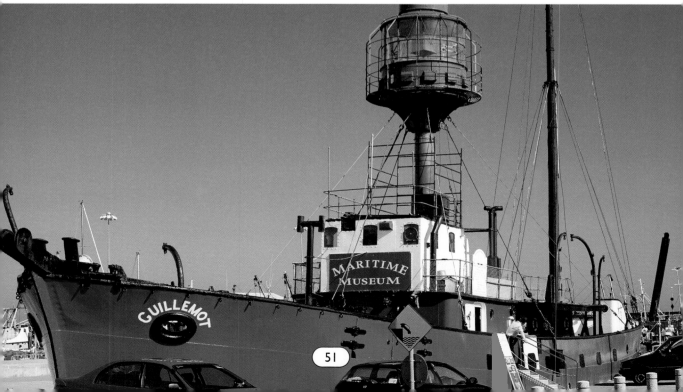

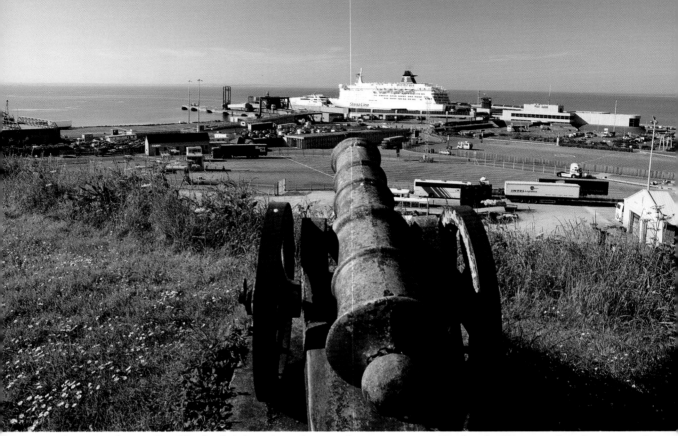

*Rosslare Harbour, Co. Wexford (above) at the south-eastern tip of Ireland. This popular ferry port is the point of entry for thousands of visitors each summer. The town of Enniscorthy (below), seen from the top of the nearby Vinegar Hill, is the principal market town in central Co. Wexford. It stands astride the River Slaney, although most of the historic town is on the western bank. Vinegar Hill was the site of the final decisive battle in the 1798 rising.*

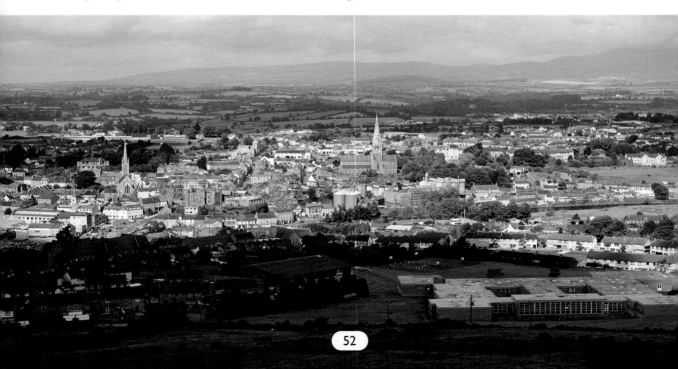

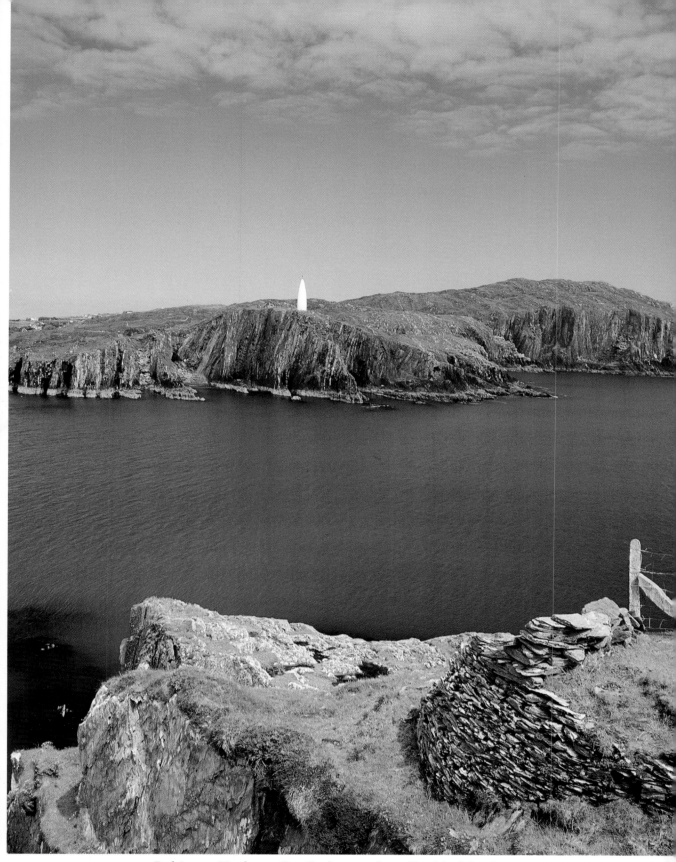

*Baltimore Harbour, Co. Cork, seen from Sherkin Island.*

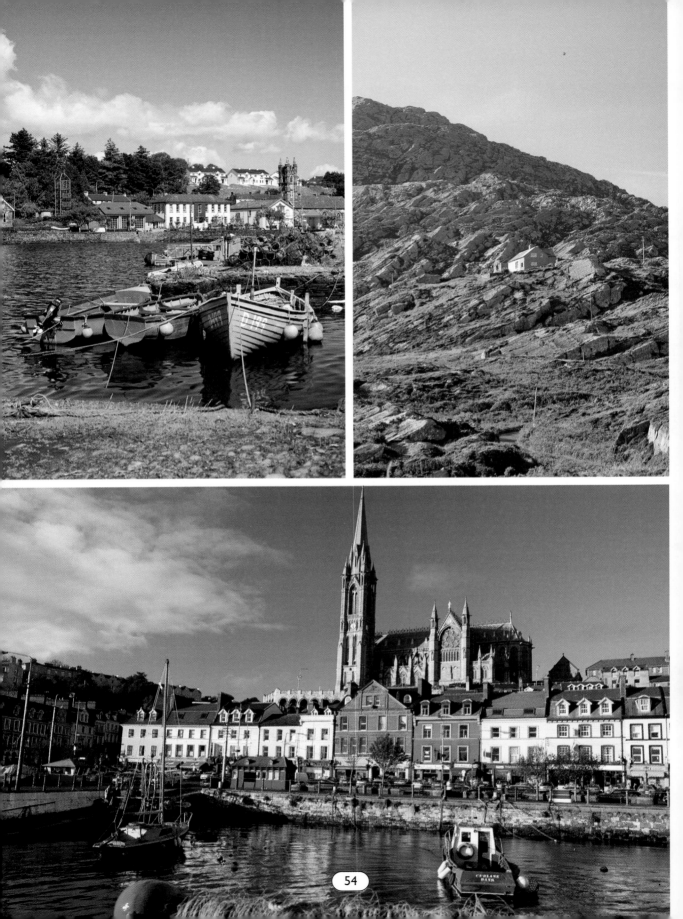

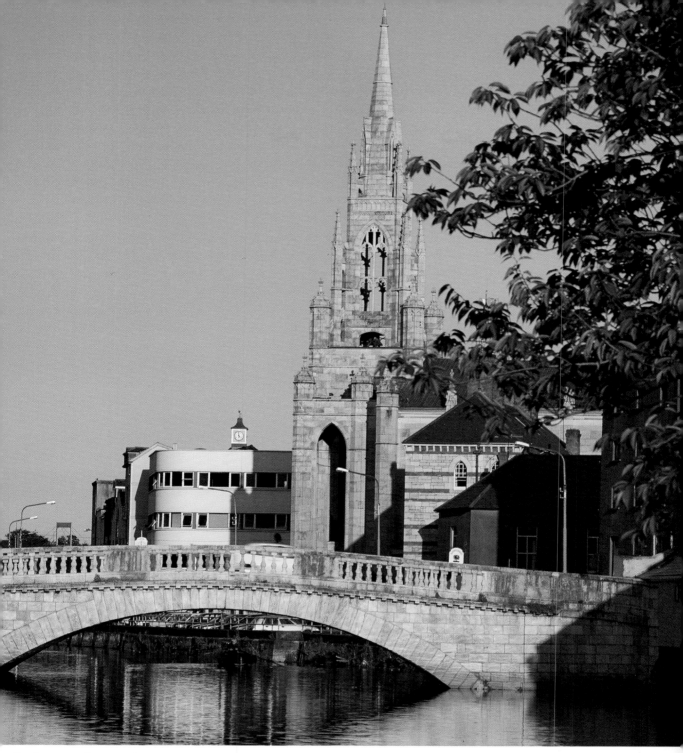

*Cork city (above), showing one of the channels of the River Lee with the Father Mathew church in the background. Cork is the second city of the republic. Co. Cork is the largest county in Ireland and has a wide variety of landscape and terrain. The west of the county is rocky and rugged (opposite top right). It contains scenically situated towns like Bantry (opposite top left) standing at the head of the great bay of the same name. Cobh – formerly Queenstown – (left), with its magnificent cathedral and beautifully maintained seafront, is the port of Cork and stands in the centre of a superb natural harbour.*

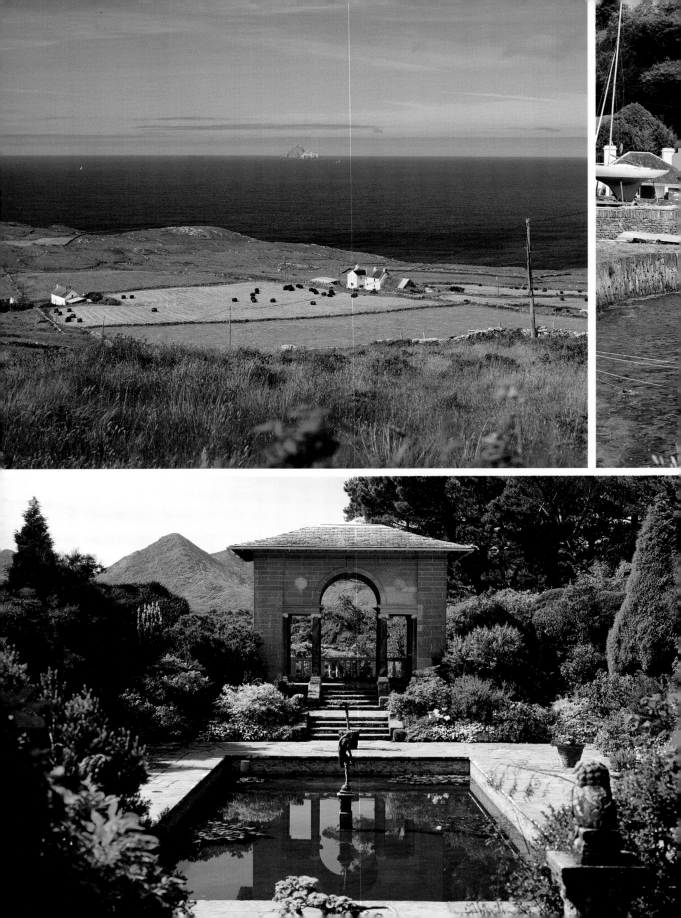

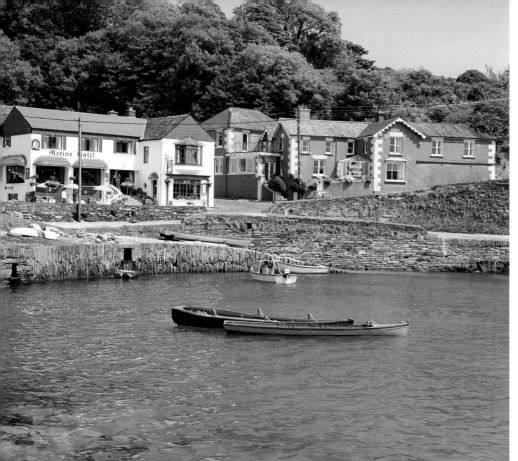

A marine landscape on the Beara Peninsula with the great Skellig Rock standing out to sea in the background (far left). The little harbour at the Glandore, Co. Cork (left). The beautiful Italianate gardens at Garinish Island just off the coast at Glengarriff (below left) contrast with the quaint corrugated iron shop in the village of Inchigeela (below).

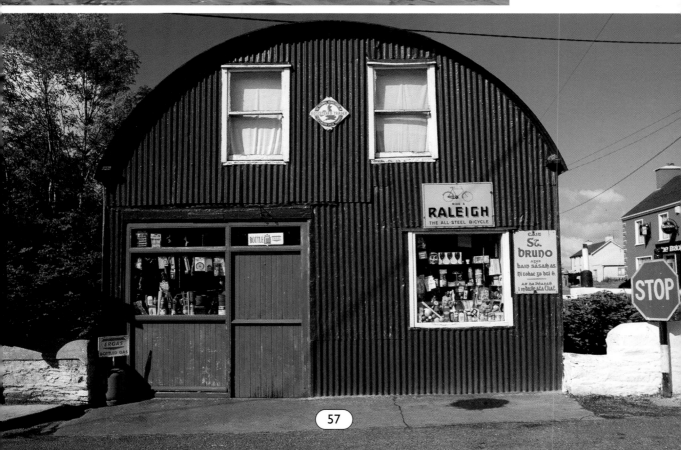

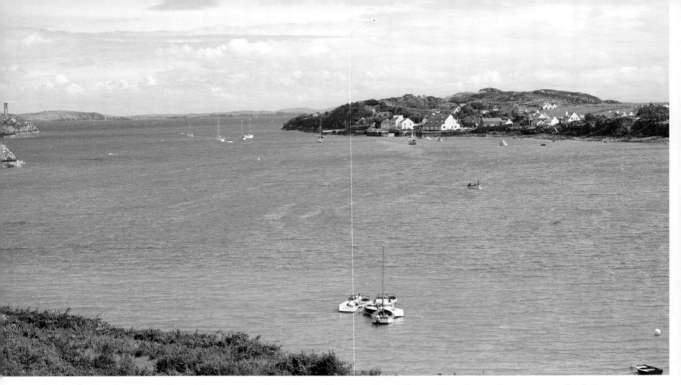

*The little harbour of Crookhaven on the Mizen Peninsula. Mizen Head, at the very end of the peninsula, is the most southerly point in Ireland (above). The placid lake and the church at Gougane Barra (below). St Finbarr founded a religious house here in the sixth century: from this inland hermitage, the saint went on to found the settlement that later became the city of Cork. Roches Point (opposite top) stands at the end of the peninsula that encloses Cork harbour on the eastern side. The rugged marine landscape near Allihies in the west of the county (opposite bottom left) contrasts with the neat civic order of the houses in Allihies village (opposite bottom right).*

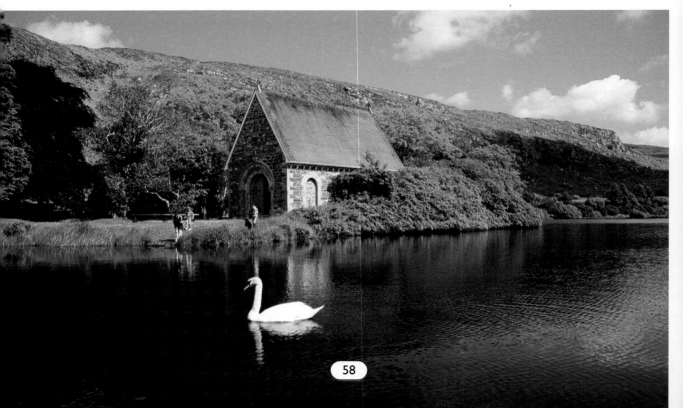

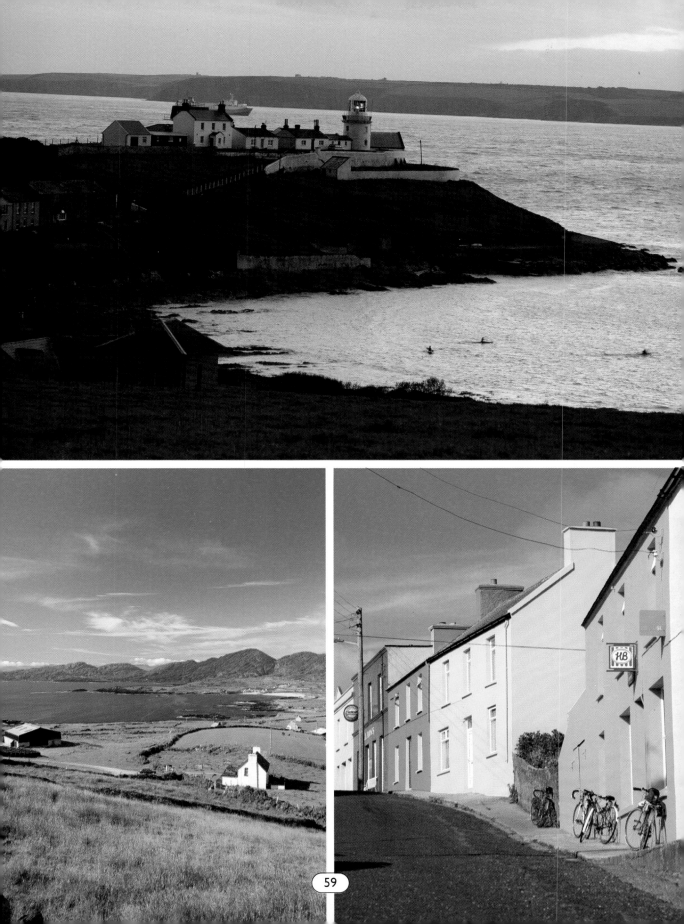

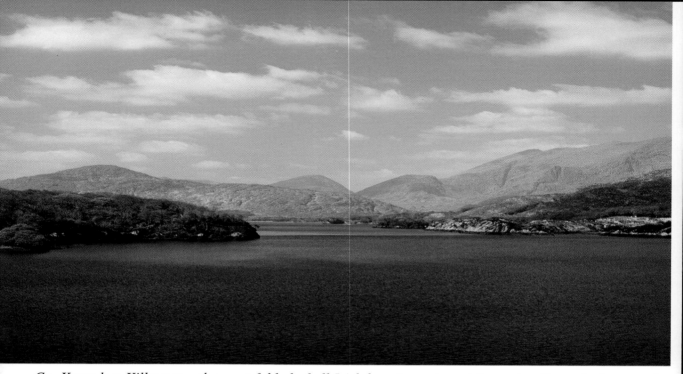

*Co. Kerry has Killarney – the most fabled of all Irish beauty spots – at its centre. From the beauty of the Lower Lake (above) to the wildness of the Hag's Glen (below) to the panorama from Ladies' View (opposite above left), there is always something to hold the eye. The Dingle Peninsula ends at Slea Head (opposite below). In the flatter north of the county, Ballybunion Castle (opposite above right) looks into the sunset.*

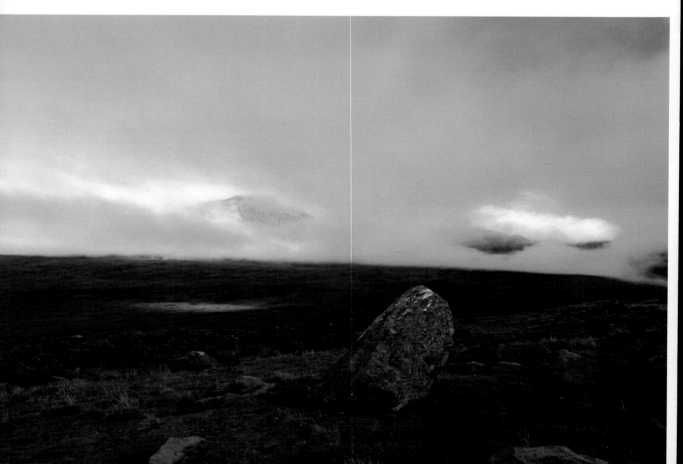

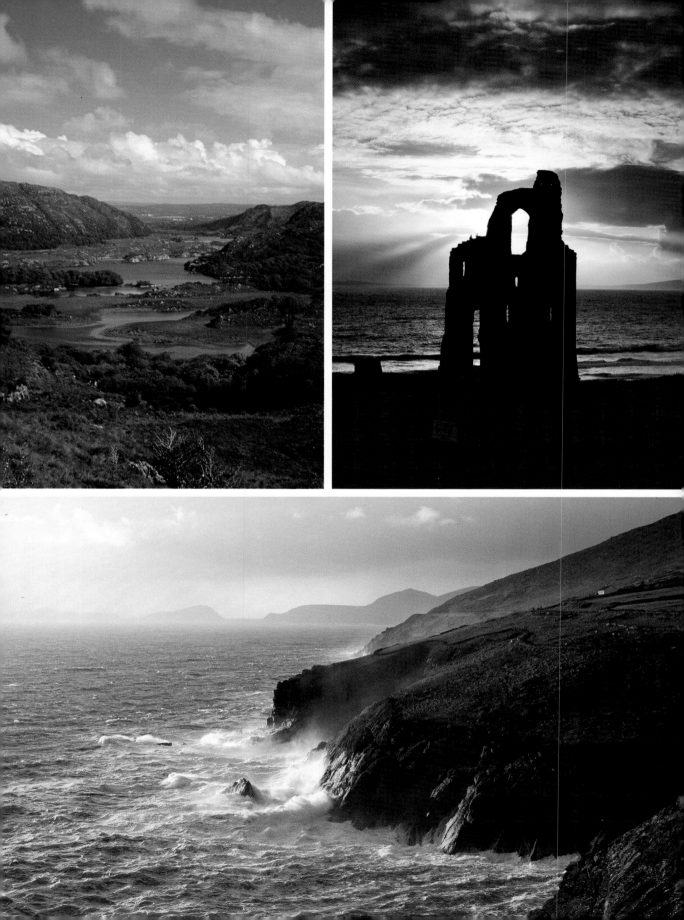

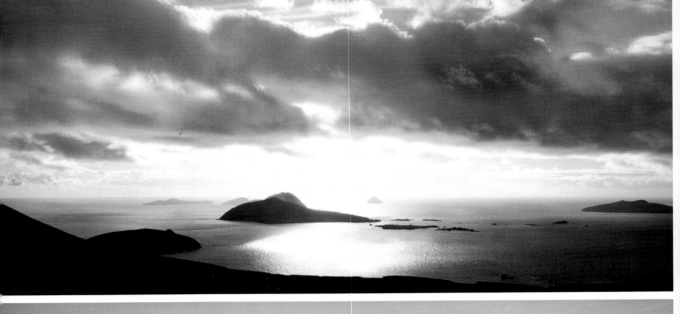

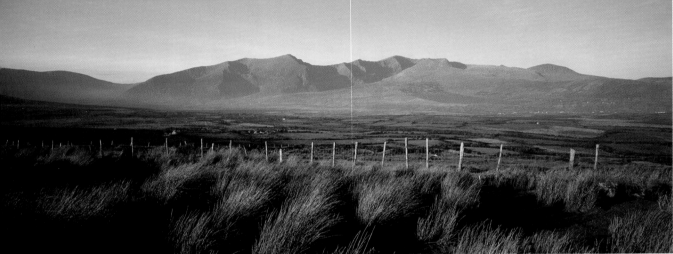

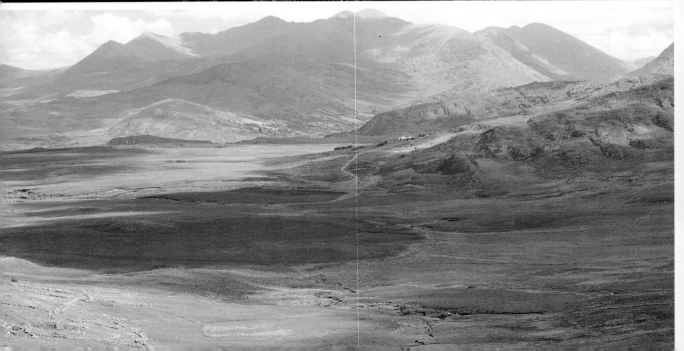

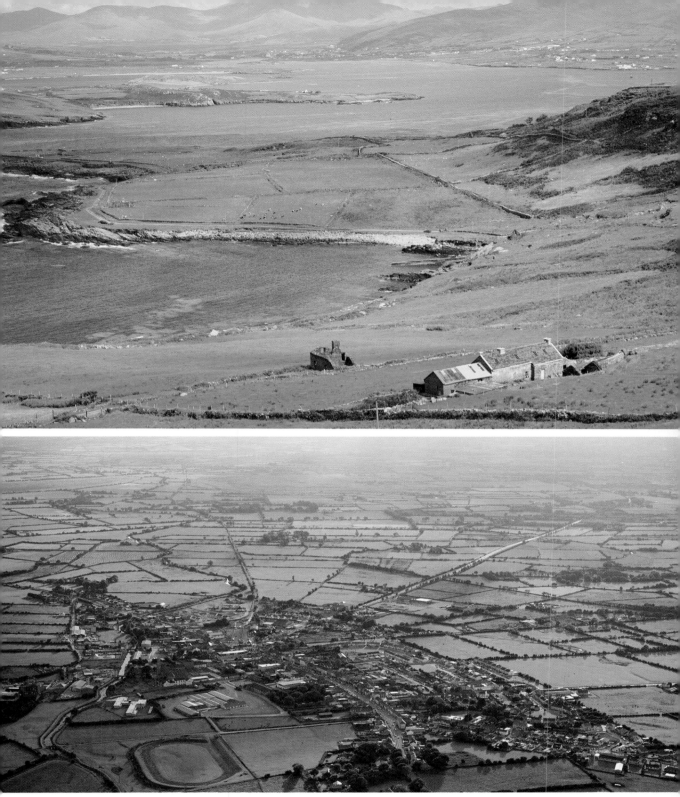

*The Blasket Islands (opposite top) seen from Dunquin at the end of the Dingle Peninsula. The Conor Pass (opposite centre) also on the Dingle Peninsula. The remote and hauntingly beautiful valley of Glencar near Killarney (opposite below). Valencia Harbour with the town of Caherciveen in the background (top). An aerial view of Castleisland in the east of the county (above).*

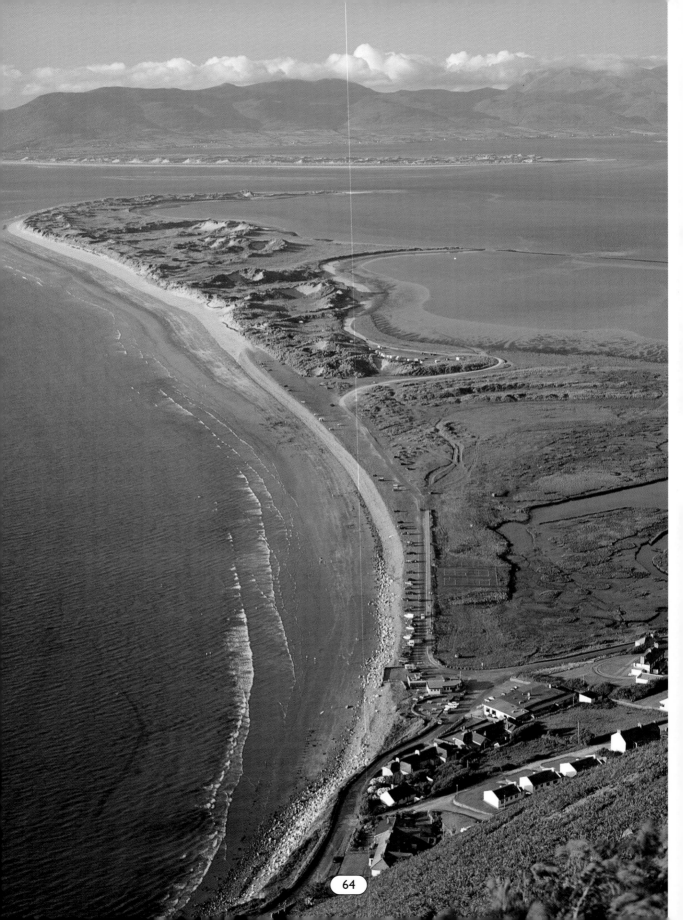

*The wonderful strand at Rossbeigh on the south side of Dingle Bay with the equally beautifully Inch strand in the background (opposite). A ruined house in Black Valley near Killarney (above). The abandoned village on the Great Blasket Island, whose last inhabitants re-located to the mainland in 1953 (below).*

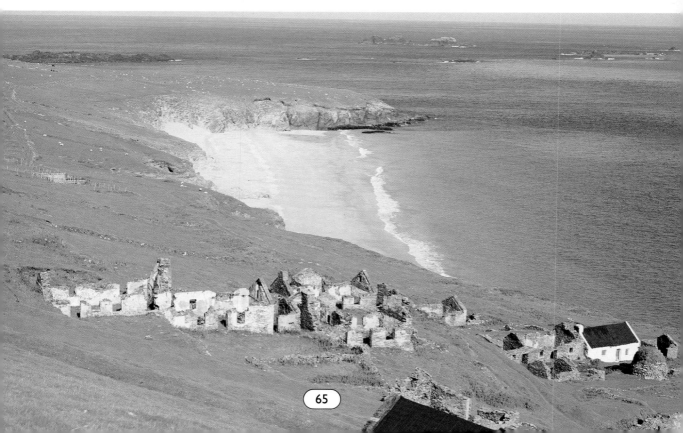

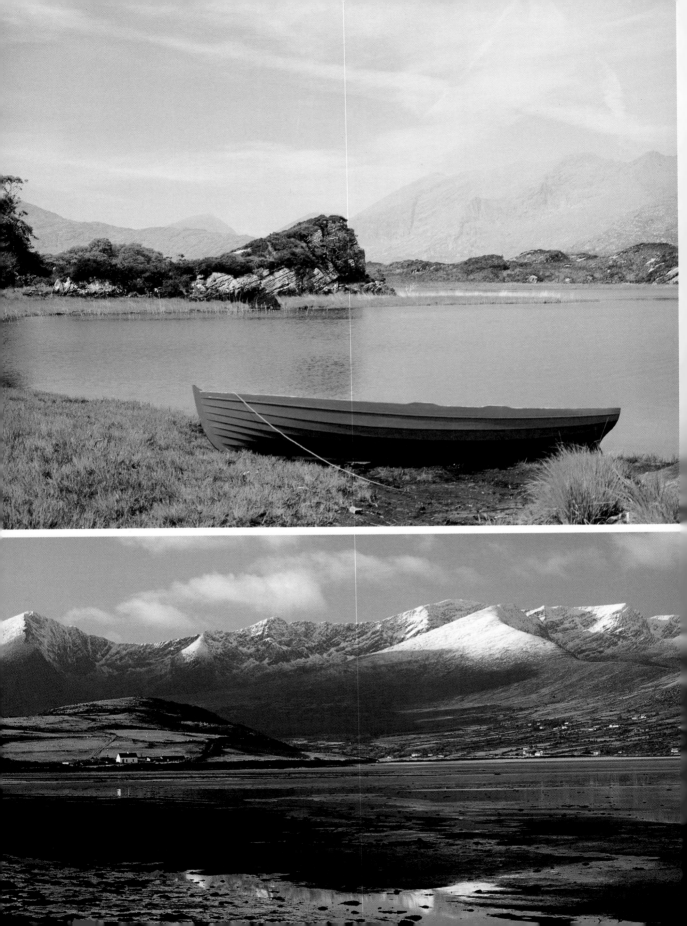

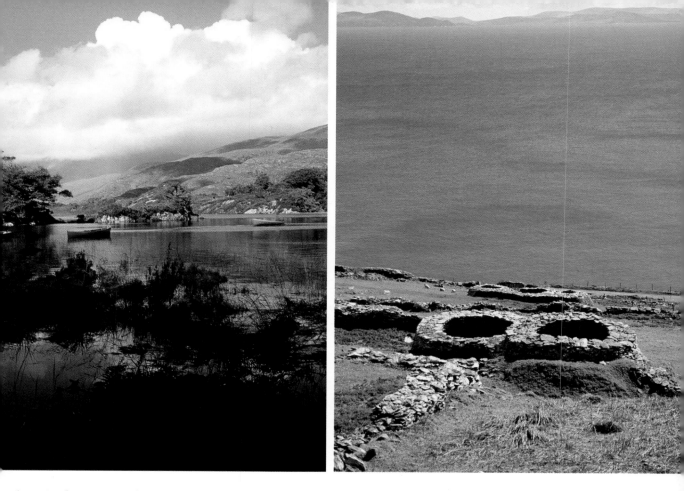

*A typical scene on the Ring of Kerry (opposite above). Looking towards Mount Brandon in winter (opposite below). A corner of the Upper Lake in Killarney (above left). The remains of medieval 'beehive' settlements at the western end of the Dingle Peninsula (above right). Dunmore Head (below) is technically the most westerly point in Ireland. The Great Blasket Islands are in the background.*

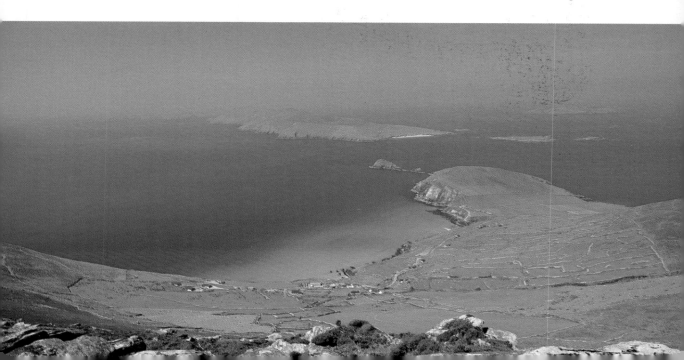

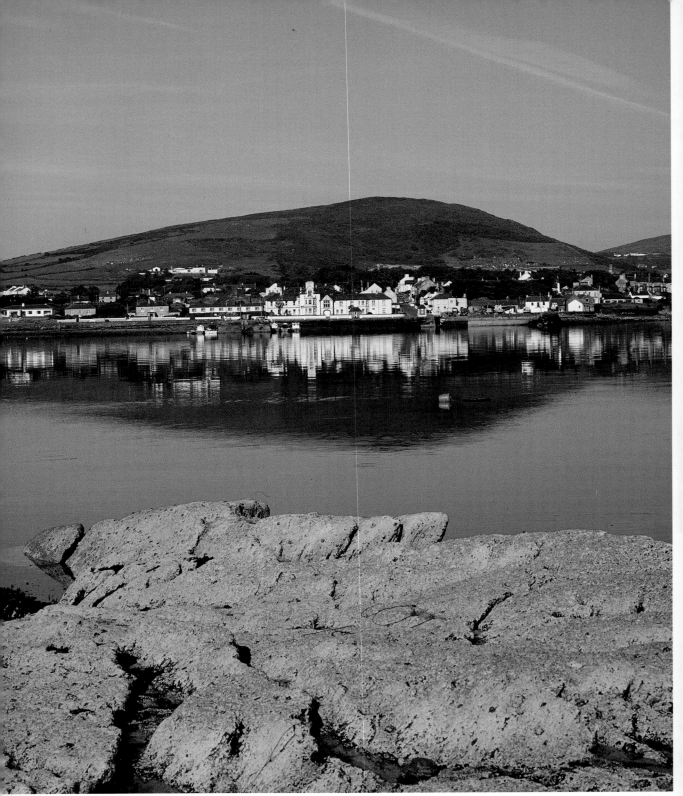

*Knightstown, on Valencia Island, Co. Kerry, reflected in the waters of Valencia Harbour (above). The view eastward at Bearnagh Gap, Co. Limerick (opposite above) as dawn breaks over the fertile lowlands of the Golden Vale. Standing as it does astride the estuary of the Shannon, Co. Limerick has been a magnet for settlers from earliest times. It is rich in history. At Lough Gur lie the remains of the country's oldest stone circle.*

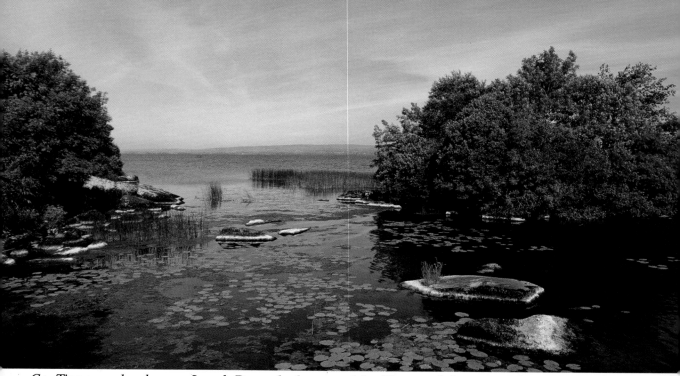

Co. Tipperary borders on Lough Derg, the largest of the Shannon lakes seen (above) from Garrykennedy and (opposite below) from near Portroe looking across to the hills of Co. Clare. Much of Tipperary is part of the flat, fertile Golden Vale, in the midst of which stands the ruined abbey of Cashel Hore (below). The old tower house at Dromineer on Lough Derg makes a fine silhouette in the sunset (opposite above left) while a small stream flows through the Glen of Aherlow in the heart of the Golden Vale (opposite above right). Following page: The view from the Vee above Clonmel (top). Farmland near Slievenamon (below left). A ruined church and graveyard near Lough Derg (below right).

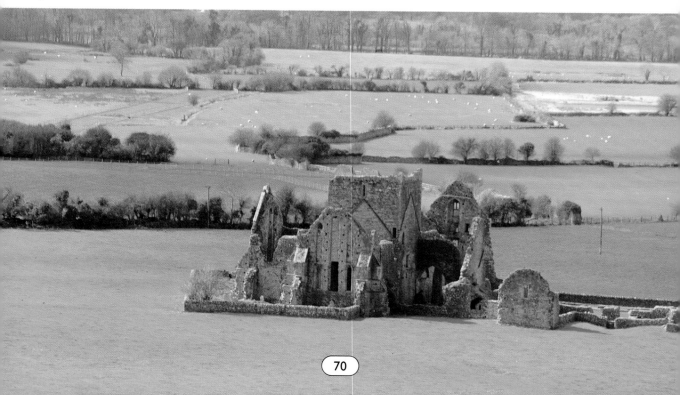

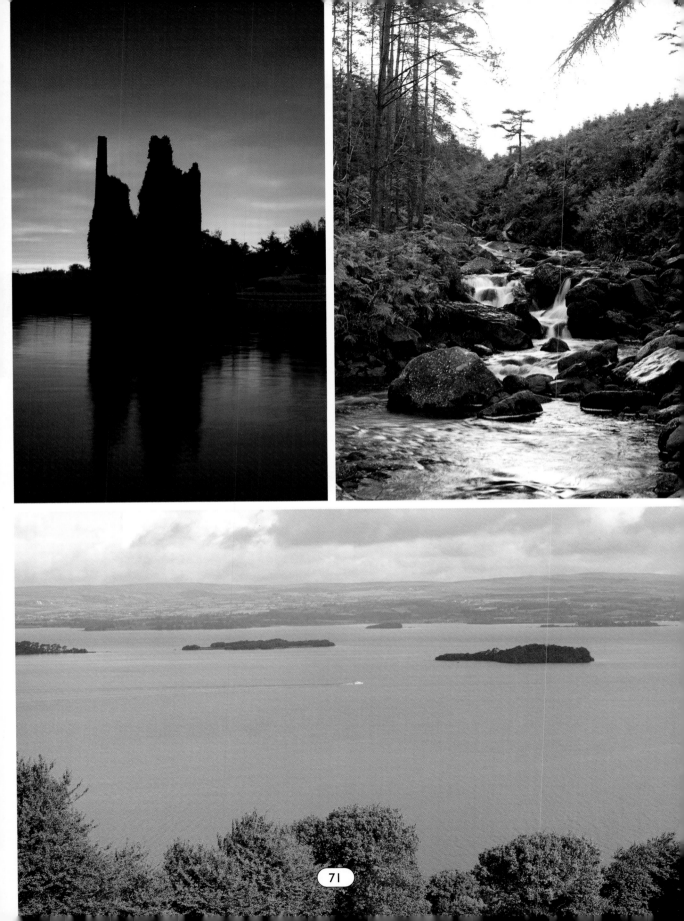

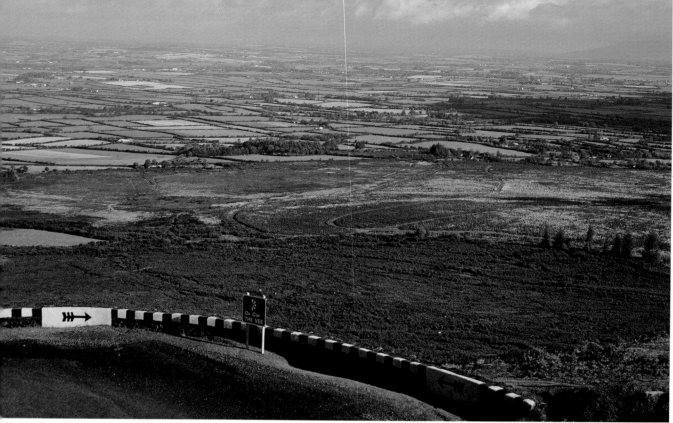

*The west is a land of stone. Dry-stone walls such as this are typical of the region (left). Holy Island in Lough Derg seen from the Co. Clare side (below).*

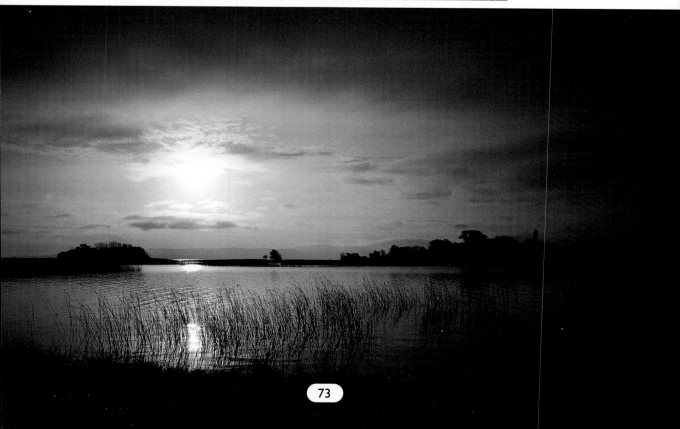

*Co. Clare falls naturally into three regions. The north of the county is distinguished by the extraordinary limestone landscape of the Burren. The Atlantic coast affords a series of splendid marine views, as at Loop Head (right). The east of the county, bordering on the Shannon and Lough Derg, is less rugged but still very beautiful. The quay at Scarriff (below) on Lough Derg is a popular mooring place for pleasure craft. The bridge at Killaloe (below right) which links east Clare to Ballina in Co. Tipperary is the principal crossing point at the southern end of the lake.*

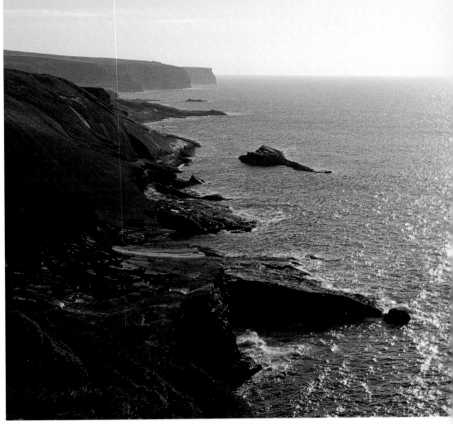

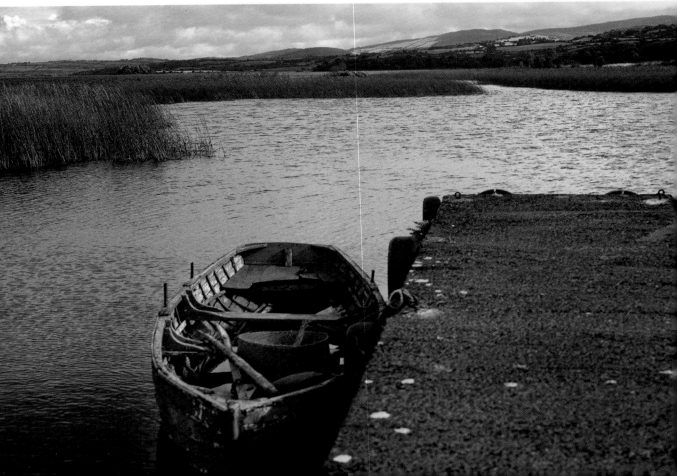

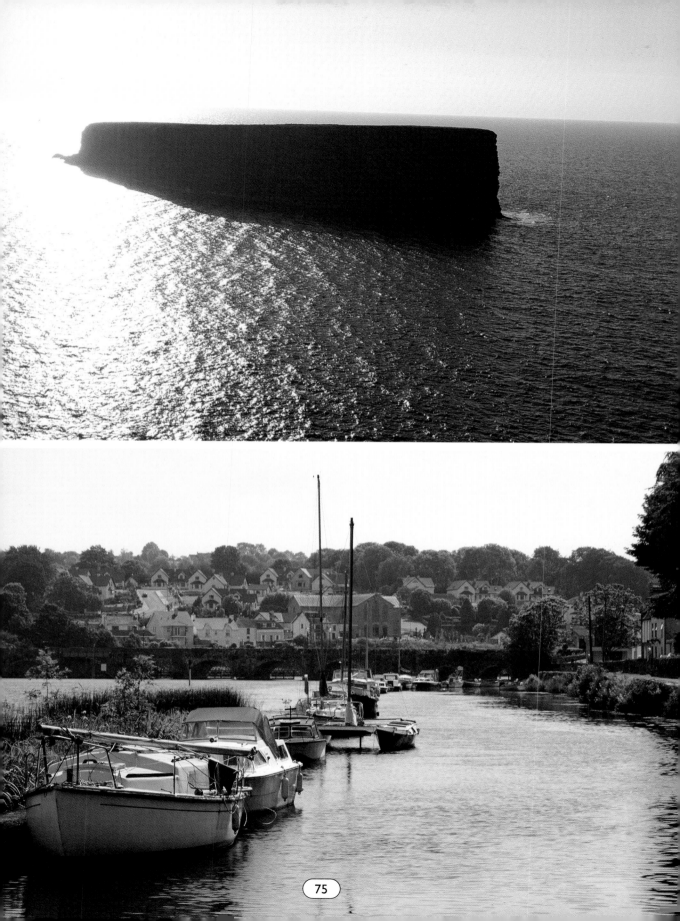

*The Burren (above and opposite bottom right) is a word derived from the Irish boireann, a rocky place. It covers an area of over 250 square kilometres in north Co. Clare. The covering of limestone allows an amazing variety of rare plants to flourish in the cracks between the rocks. Many of these plants are unknown elsewhere in Europe outside the Alps. The Cliffs of Moher (opposite top) are the tallest cliffs in Ireland. The coast at Liscannor (right).*

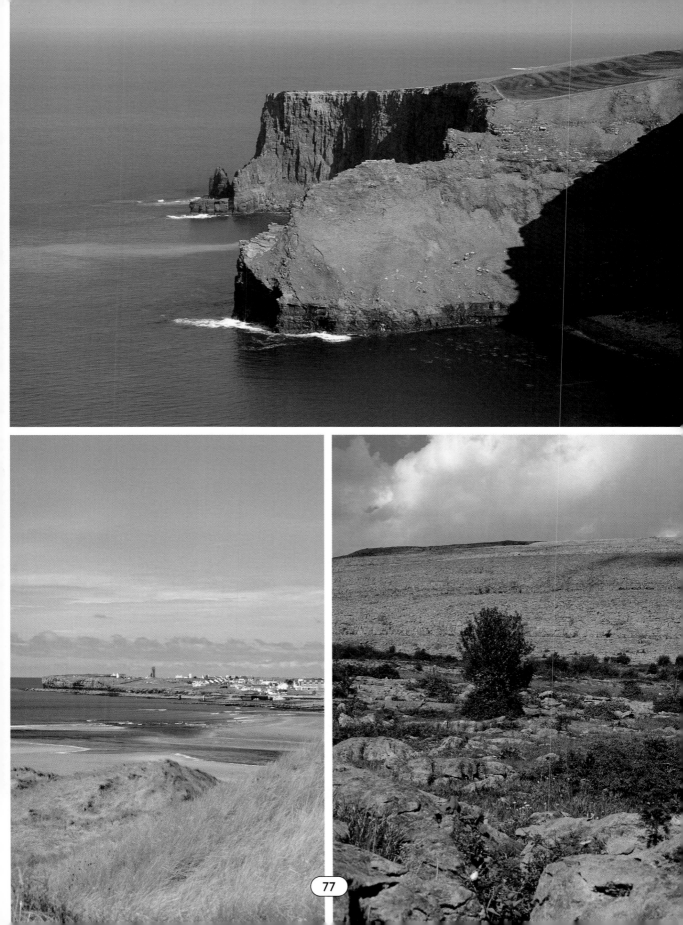

*Co. Galway is one of the most popular visitor destinations in Ireland, drawing tens of thousands of people each year. Along with the lively university city of Galway, there is a wonderful variety of landscapes in the county. From the coast near Clifden in Connemara (right) to the astonishing stone-walled mazes of the Aran Islands (below) to the vastness of the great fjord at Killary Harbour (below centre) – where is was said the entire Royal Navy could anchor safely in the days of British rule – to the town house and castle of Dunguaire at Kinvara (below far right): Co. Galway has something for everyone.*

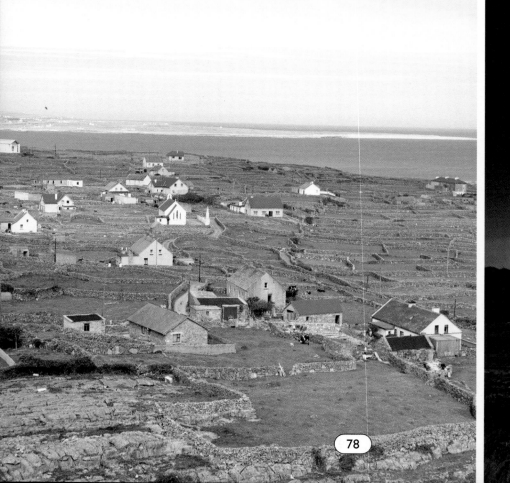

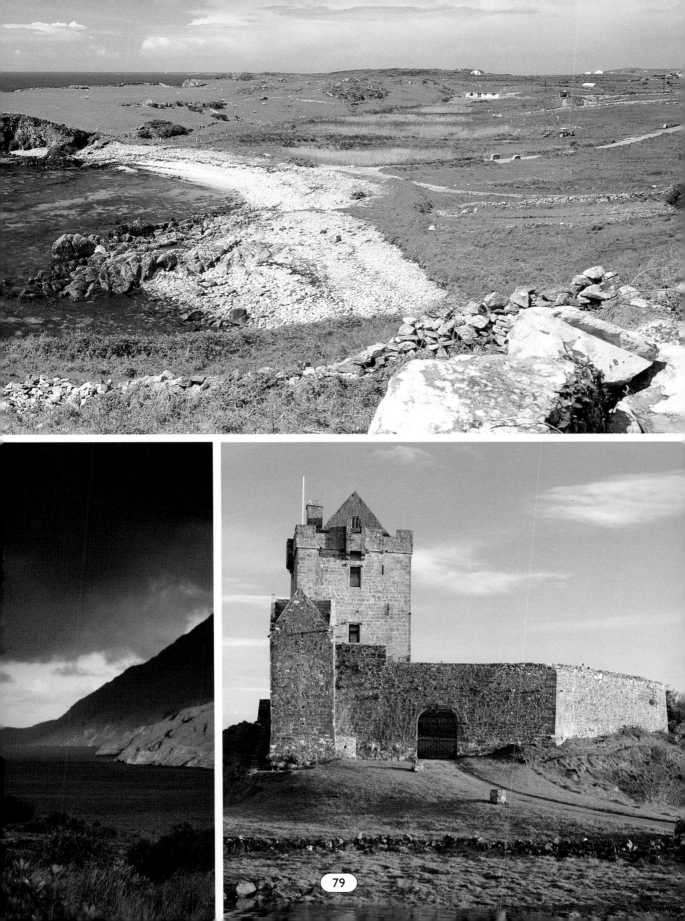

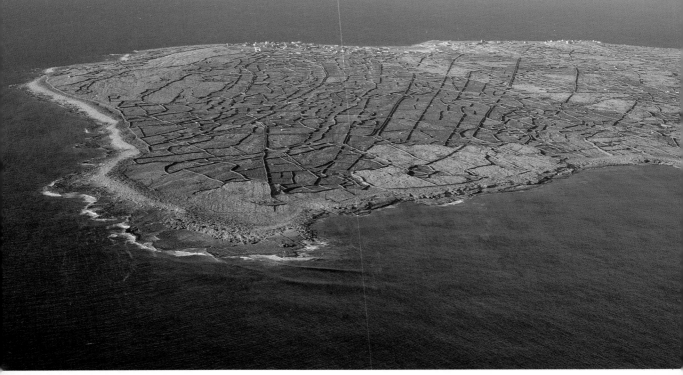

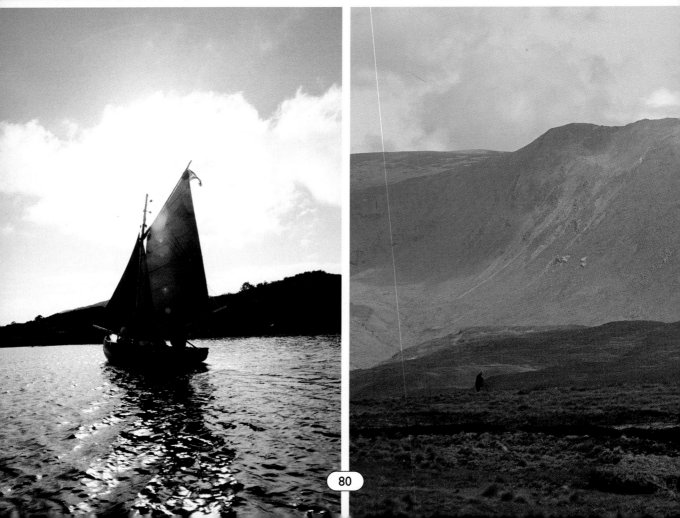

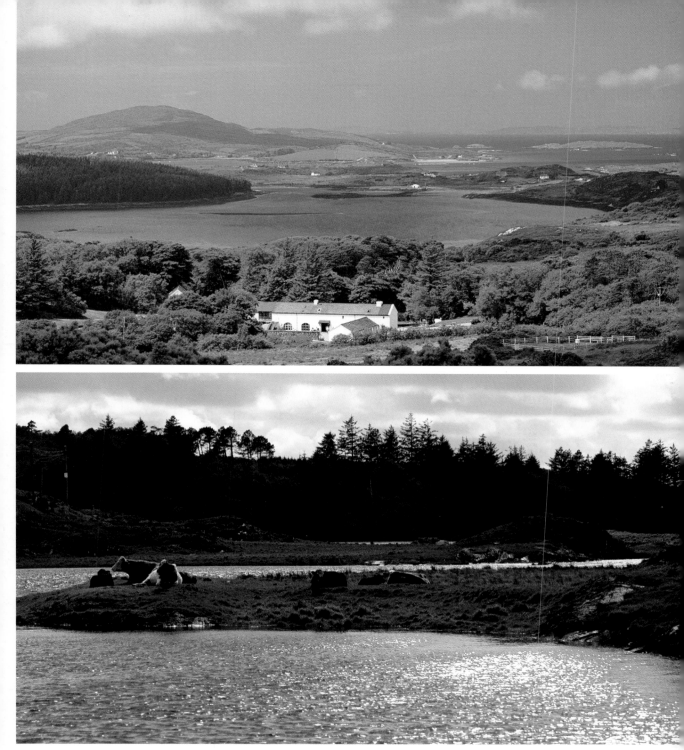

*An aerial view of Inis Mór (opposite top) showing the astonishing stone-wall tracery so typical of the Aran Islands. The Galway hooker (far left) is a small sailing craft with a design particular to the region and well adapted to the waters of Galway Bay. The magnificent wild mountain country near Leenane (left) is typical of what draws so many visitors to this part of Connemara. But the region is not all desolate and wild, as the photographs above show. Connemara National Park (top) covers over 2,000 hectares of land near Letterfrack. The cattle by the lakeside (above) were photographed near Maam Cross.*

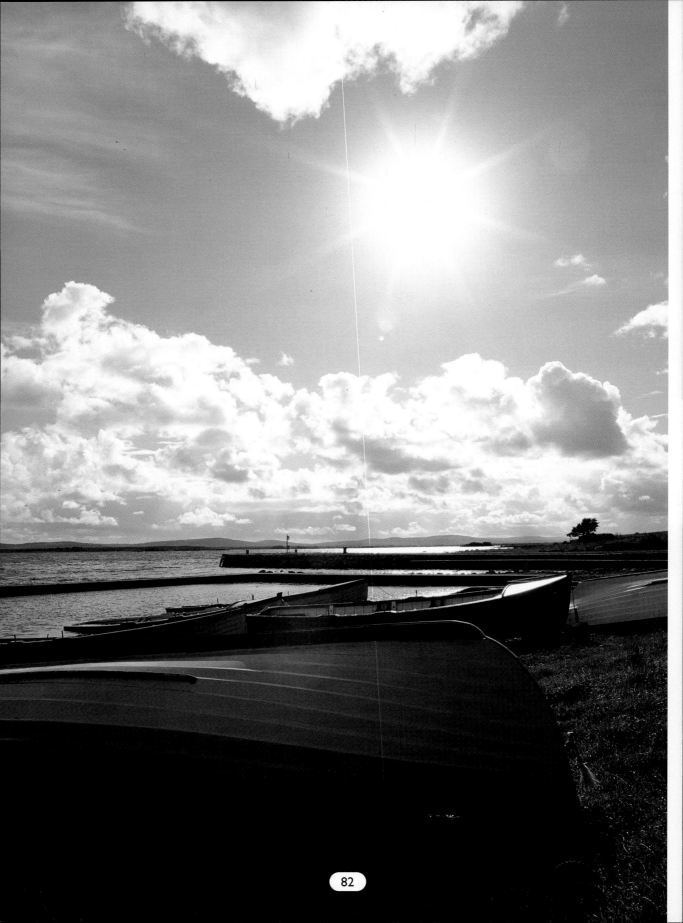

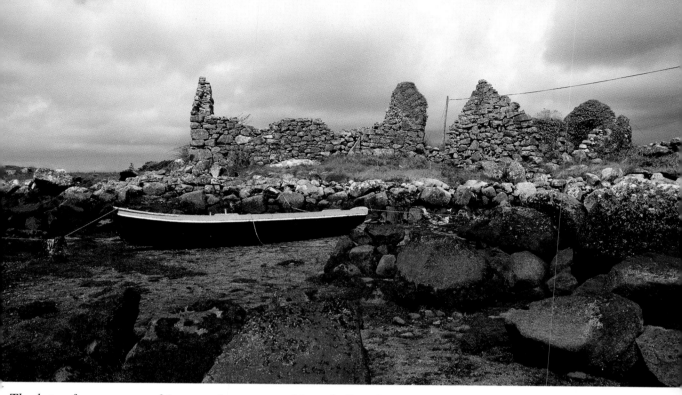

The late afternoon sun shines on the waters of Lough Corrib at Annaghdown, Co. Galway (opposite). There was an early Celtic monastery here and Annaghdown was later the see of a diocese in medieval times. The ruined cottages along the shoreline near Clifden (above) testify to the harshness of life in the west in the nineteenth and early twentieth centuries. Modern Clifden (below) has, however, prospered as a summer visitor centre and is generally and appropriately referred to as the capital of Connemara.

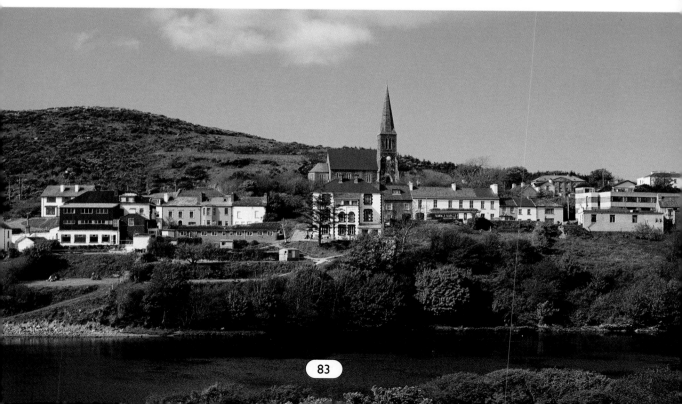

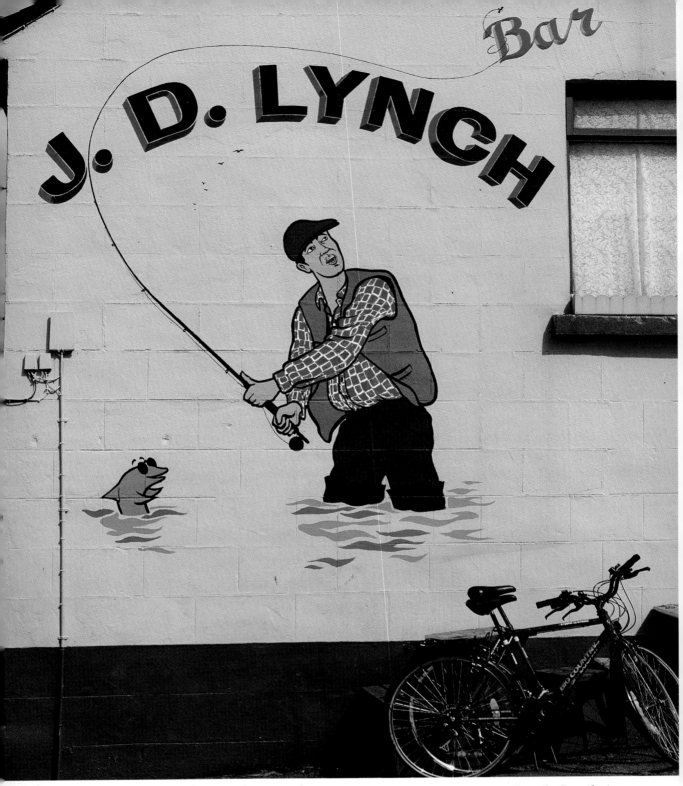

*This cheerful mural signifies Co. Galway's popularity as an angling centre. Lough Corrib, in particular, is a favourite haunt of fly-fishermen. Stooks of turf or peat (opposite top left) are stacked like this after cutting to permit the wind to dry them so that they can be burned for domestic fuel. This is a very old tradition in the west of Ireland. The pretty little harbour at Roundstone (opposite top right) with the Twelve Bens in the background. The mixture of heathland, lake, mountain and the tremendous Atlantic skies (right) are typical of Connemara landscape.*

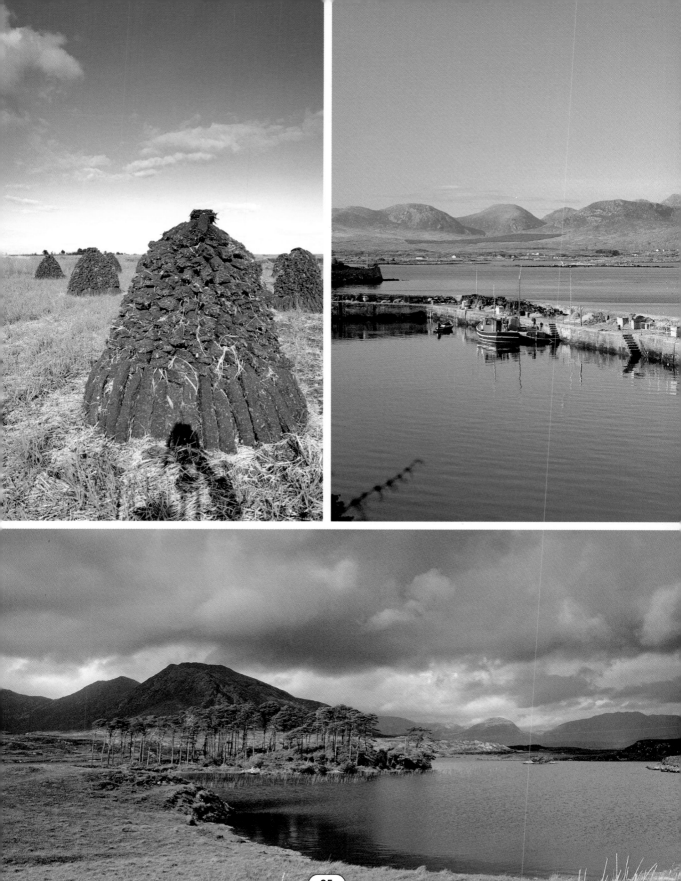

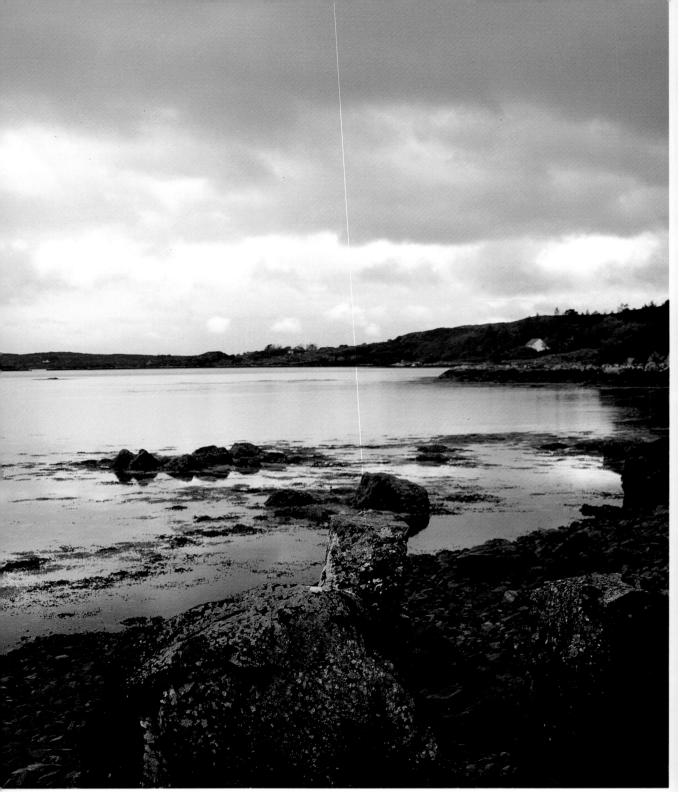

*Bertraghboy Bay near Roundstone, Co. Galway (above). Joyce's country (opposite top), on the borders of counties Galway and Mayo, is another superb wilderness of mountains and lakes. The lake here is Lough Nafooey with Benbeg Mountain in the background. Achill Island off the coast of Co. Mayo (opposite bottom left) is the largest and most populous of the islands off the Irish coast. A corner of Killary Harbour (opposite bottom right) with a threatening sky overhead.*

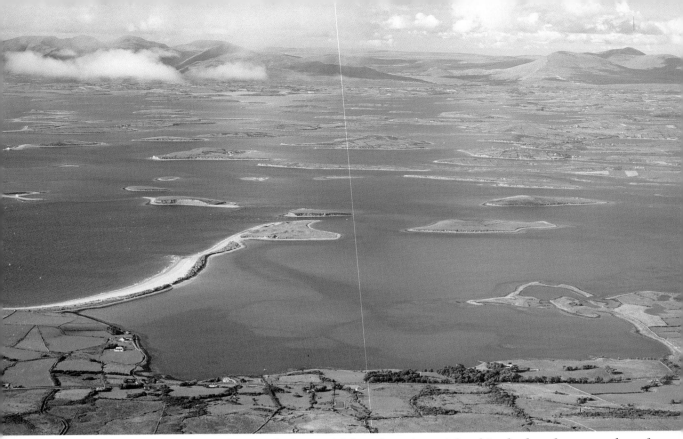

*Clew Bay from the top of Croagh Patrick. It is said that there is an island in the bay for every day of the year. Croagh Patrick (below) is a sacred mountain where St Patrick is reputed to have fasted for forty days and nights. It is the site of one of Ireland's most popular religious observances, when thousands of pilgrims climb the mountain each year. The path to the summit is clearly visible in this photograph. A cottage in the remote country between Cong and Leenane (opposite).*

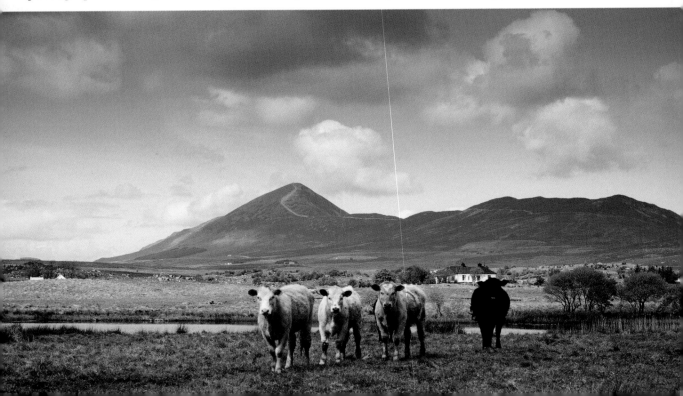

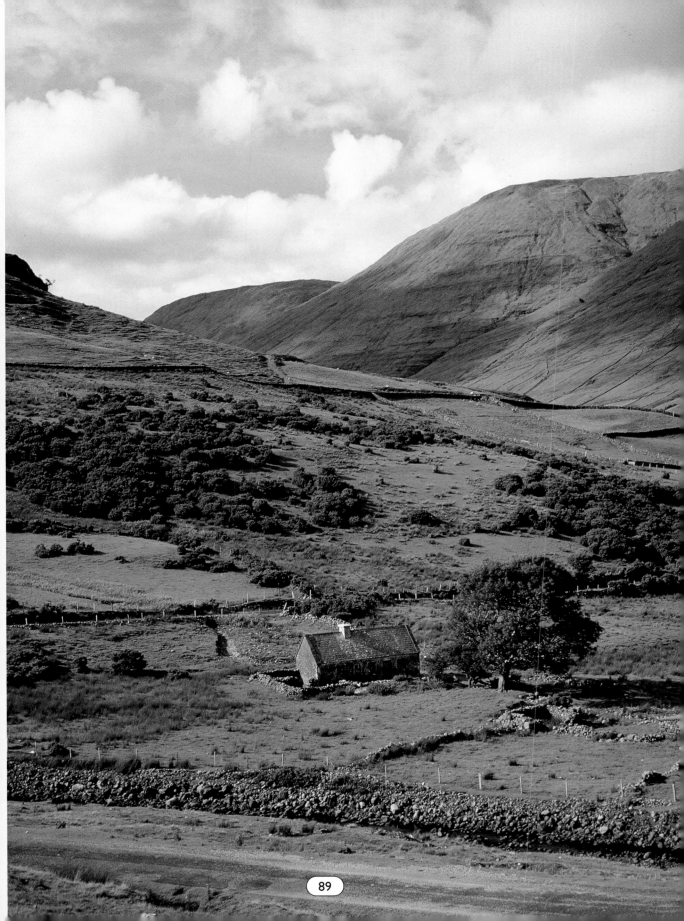

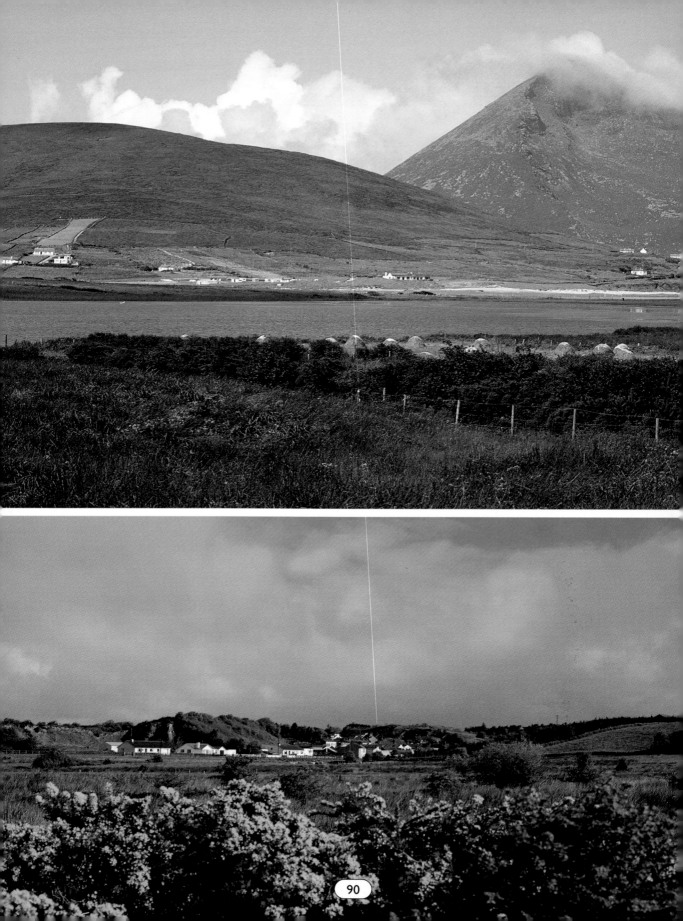

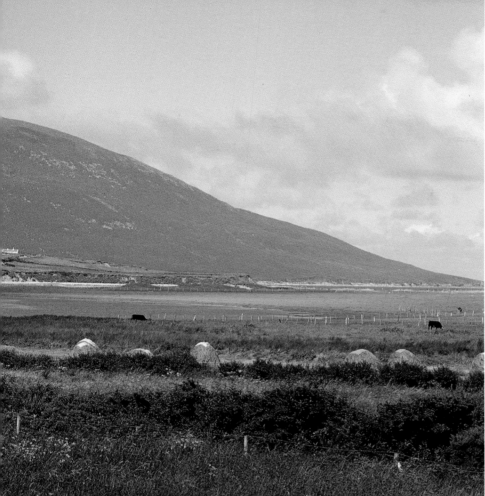

Achill Island, Co.
Mayo (left).
Some people call it
gorse, some call it
furze. In Northern
Ireland it is called
whins. But this wild
bush is universal in
Ireland and its brilliant
yellow/orange flowers
are a common sight.
This photograph
(below left) was taken
near Kilkelly, Co.
Mayo.
Killala Bay (below) on
the north Mayo coast.

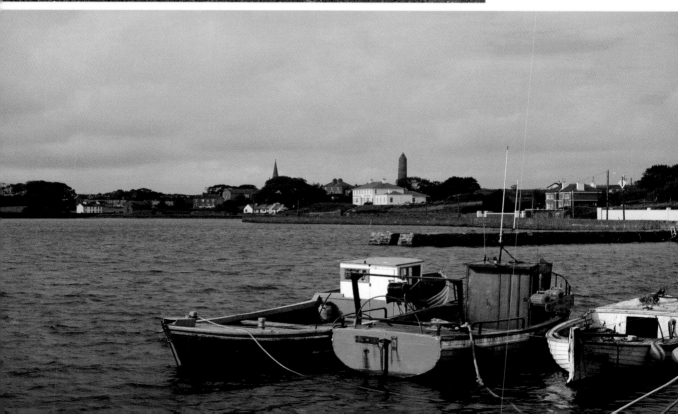

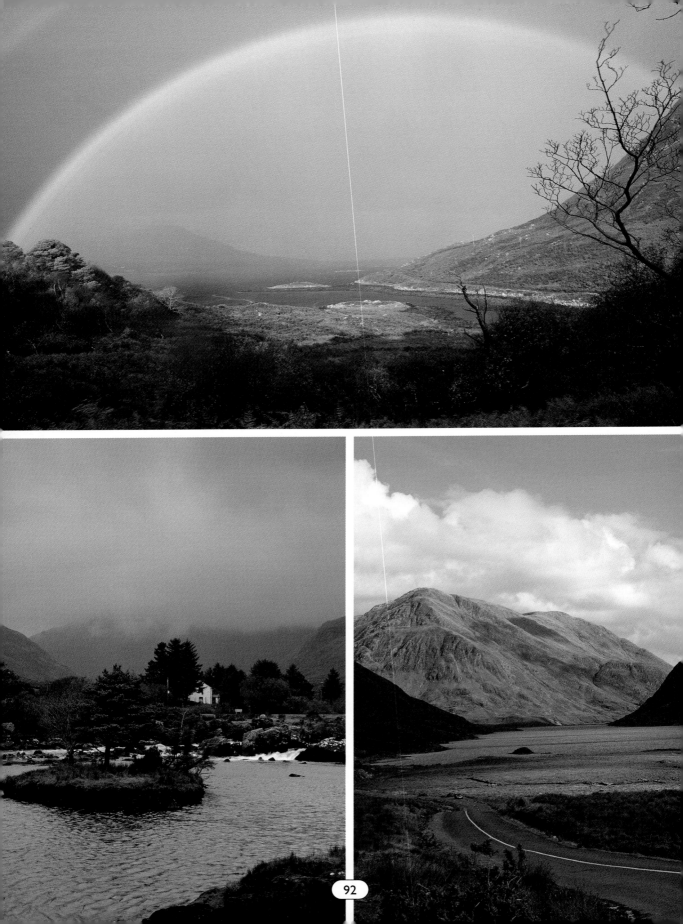

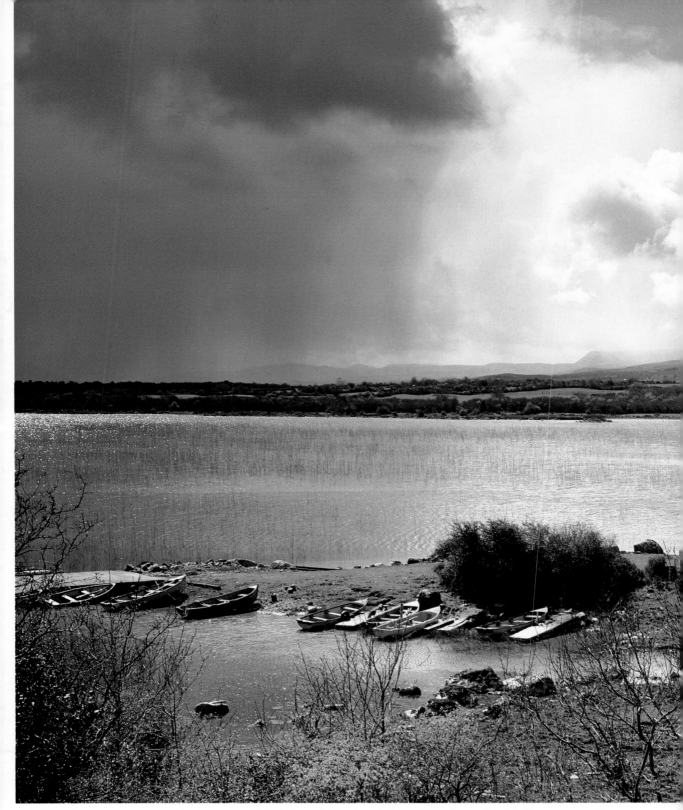

*The rainbow (opposite top) arcs over this inlet of Blacksod Bay, seen from the Mallaranny to Bangor road in Co. Mayo. A small river flows into a corner of Killary Harbour (far left), while the back road from Westport to Leenane passes Doo Lough (left). Lough Carra (above) is the smaller neighbour of Lough Mask and is a mecca for fly-fishermen.*

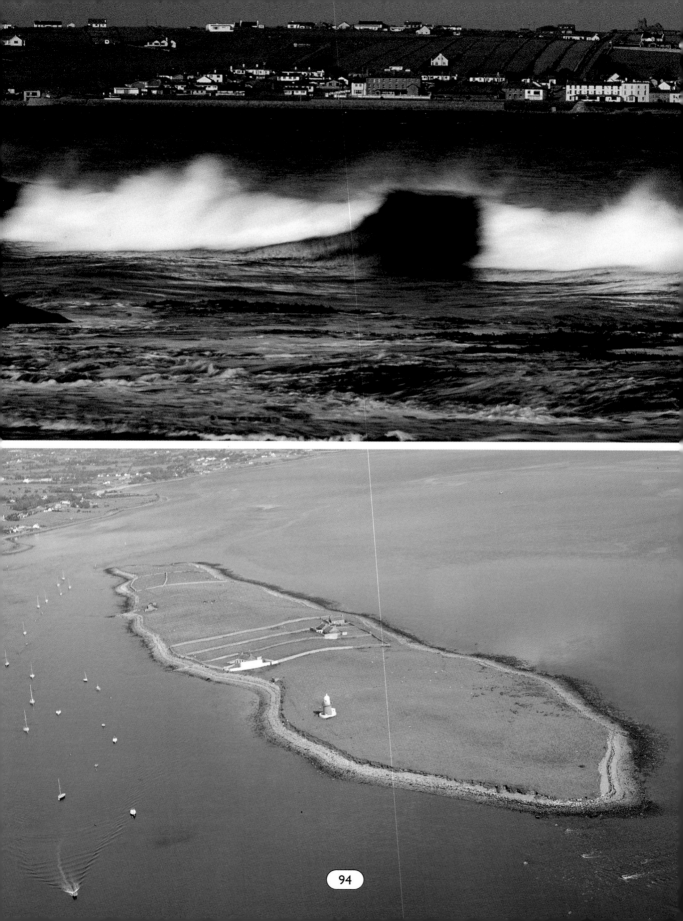

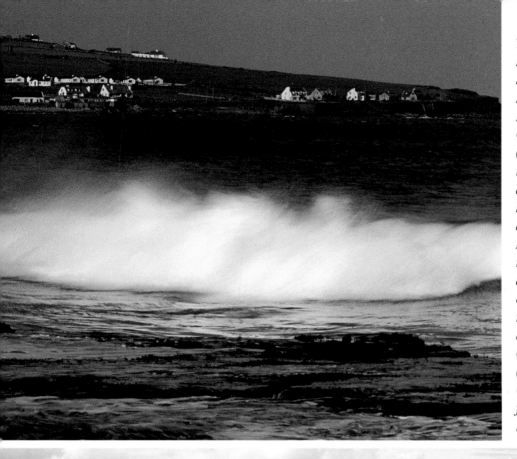

The coast at Mullaghmore, Co. Sligo on the southern shores of Donegal Bay (left). Coney Island (below left) stands in Sligo Bay on the approaches to the harbour. The distinctive Metal Man pointing out the safe channel to approaching craft can be seen towards the bottom of the island. Glencar Lake (below) is one of Co. Sligo's most famous beauty spots.

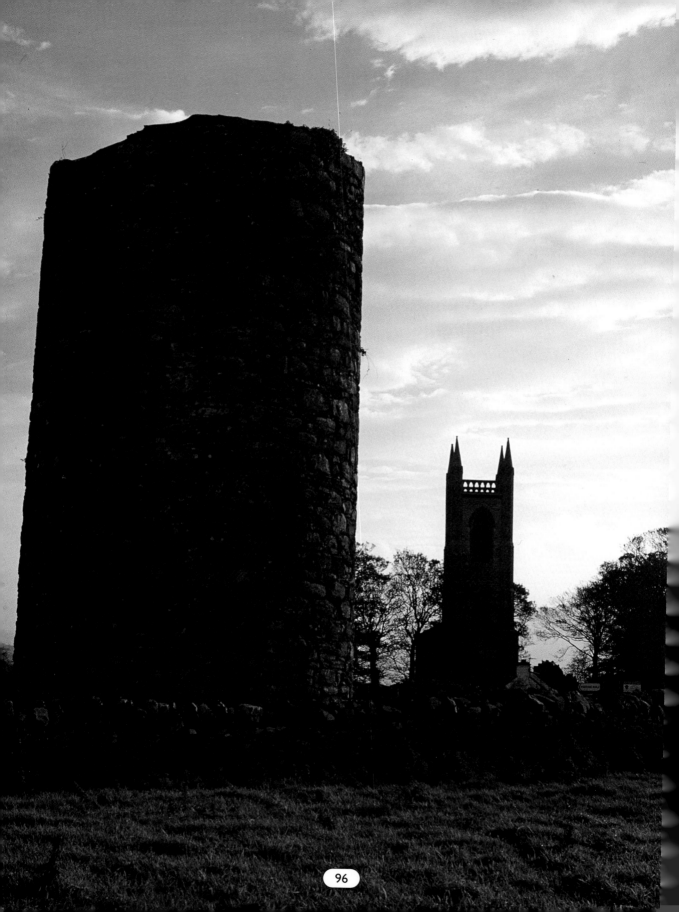

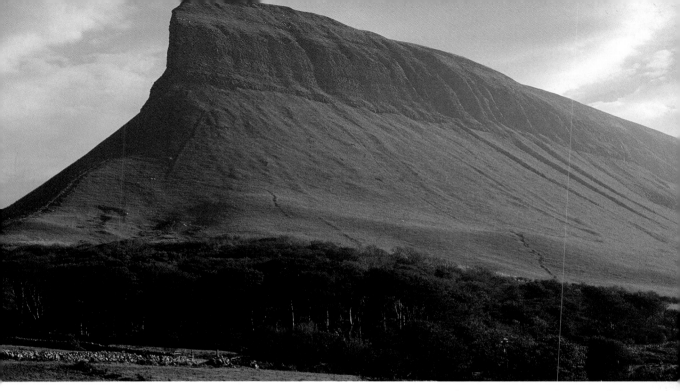

W.B. Yeats is buried in the churchyard at Drumcliff near the remains of the ancient round tower (left).
The churchyard at Drumcliff stands in the shadow of Ben Bulbin (above) probably the most distinctive
mountain in Ireland. West of Sligo town, the mountain of Knocknarea (below) commands superb views
of the surrounding countryside and also contains a cairn at its summit which is reputed to be the
burial place of the legendary Queen Maeve of Connacht.
Following page: The pretty village of Ballysadare, Co. Sligo.

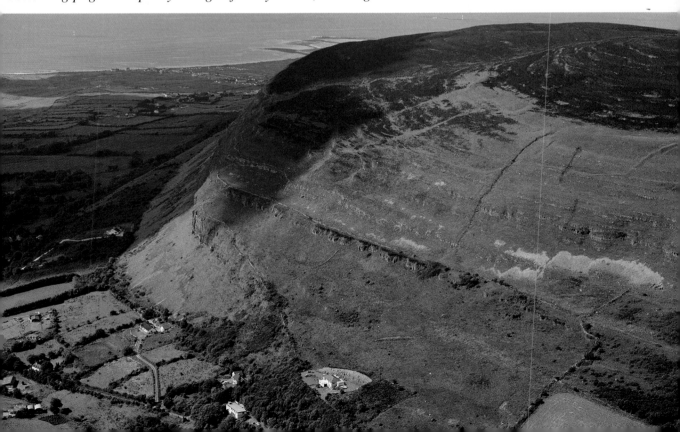

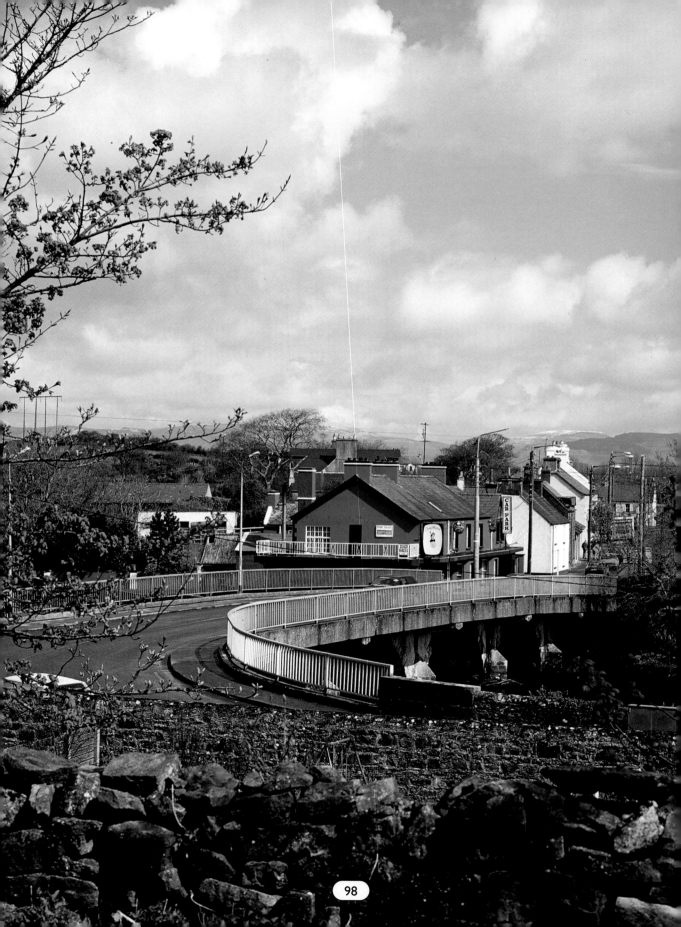

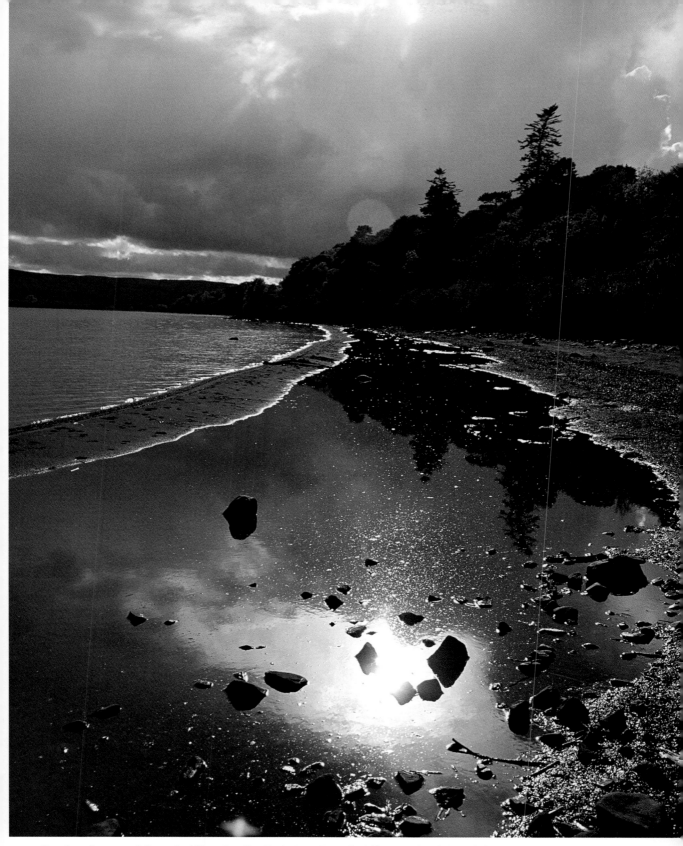

*On the shores of Lough Allen in Co. Leitrim. Lough Allen is the first of the major lakes on the Shannon system as the great river flows south.*

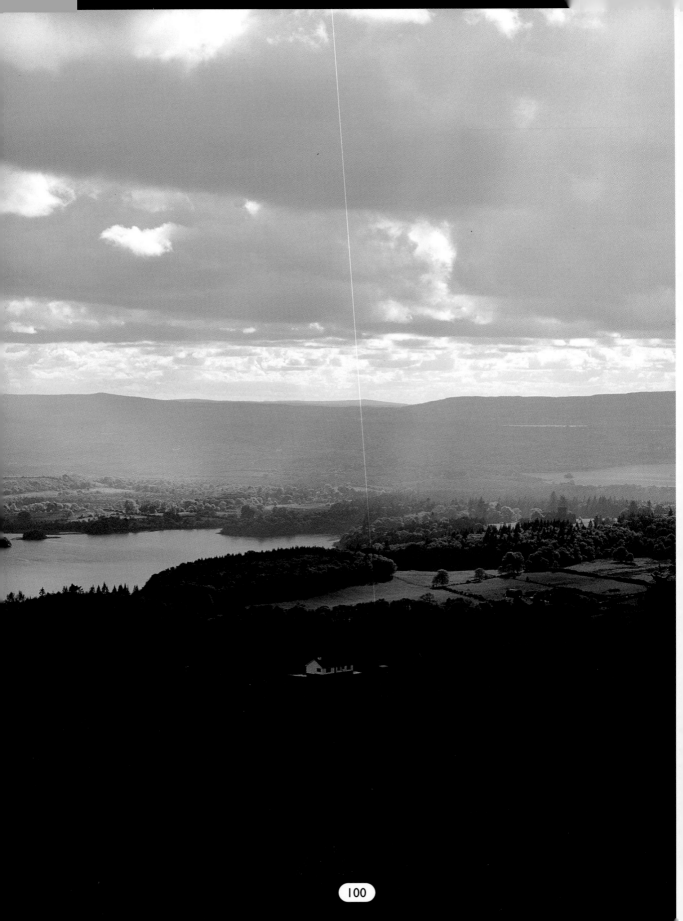

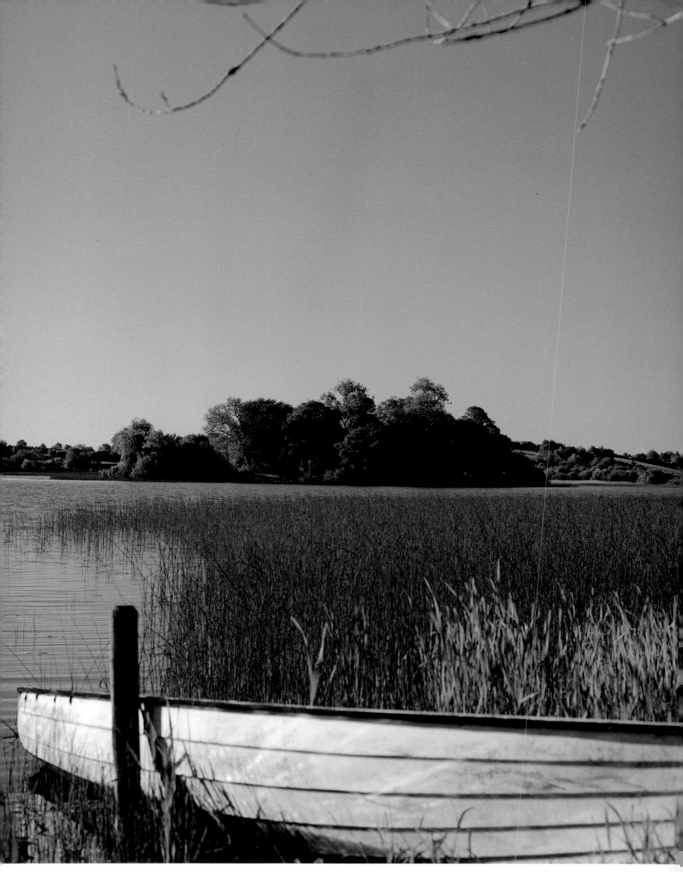

*The landscape of Co. Leitrim, seen (left) near Arigna, comprises many lakes.*

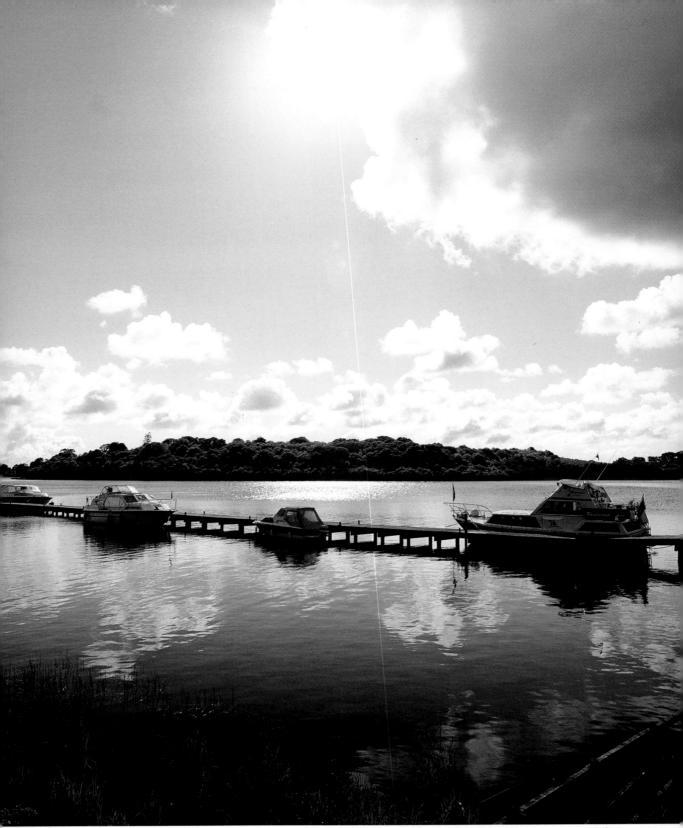

*Co. Fermanagh in the south-west corner of Northern Ireland has traditionally been one of the gateways to the province of Ulster. Its network of rivers and lakes created a natural line of defence. Upper Lough Erne (above and right) with its many islands serves a more tranquil and leisurely purpose these days.*

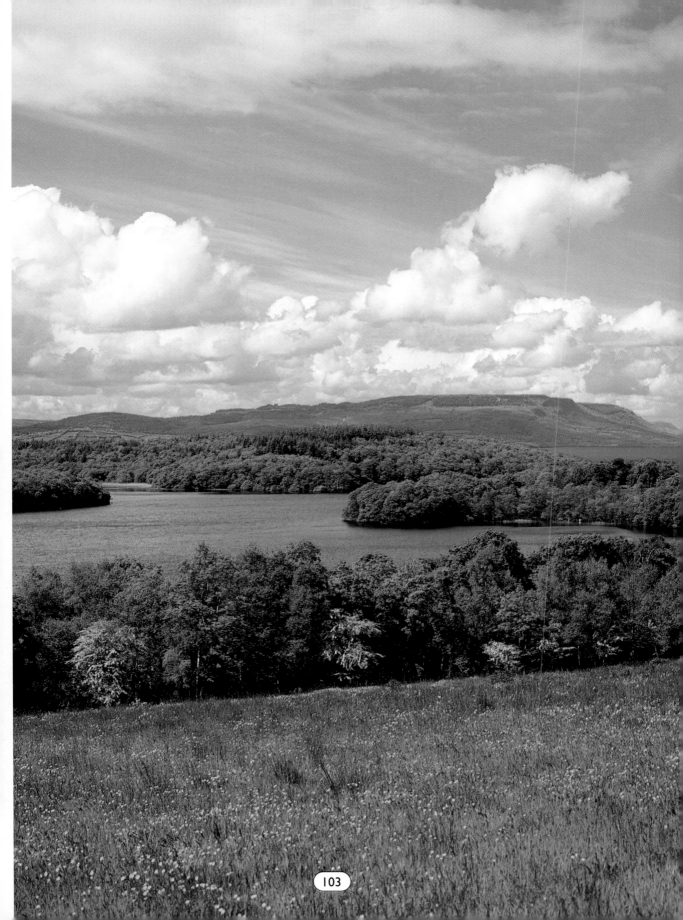

Co. Donegal, a magnificent fastness of the north-west, is a place apart. Glenveagh National Park is centred on the shores of Lough Veigh (right) and extends over 10,000 hectares of the county. On the far north-west coast, the area known as the Rosses near Gweedore is famed for its beauty. Here a small craft is beached at low tide (below). In the centre of the county, the road from Glenties to Fintown (below right) runs through desolate but beautiful upland scenery.

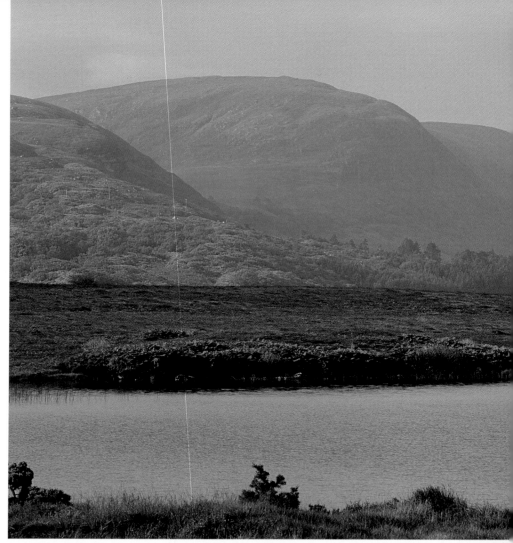

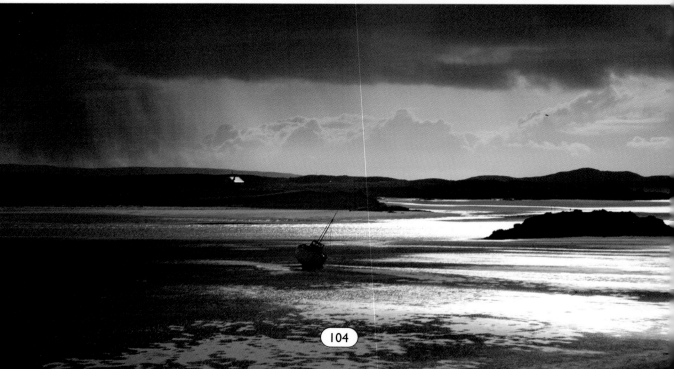

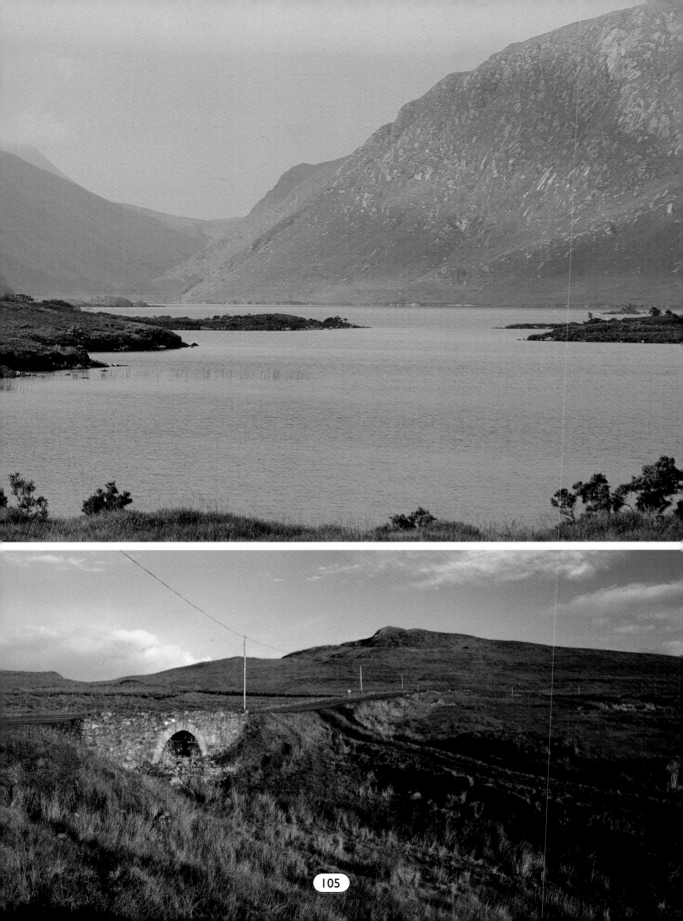

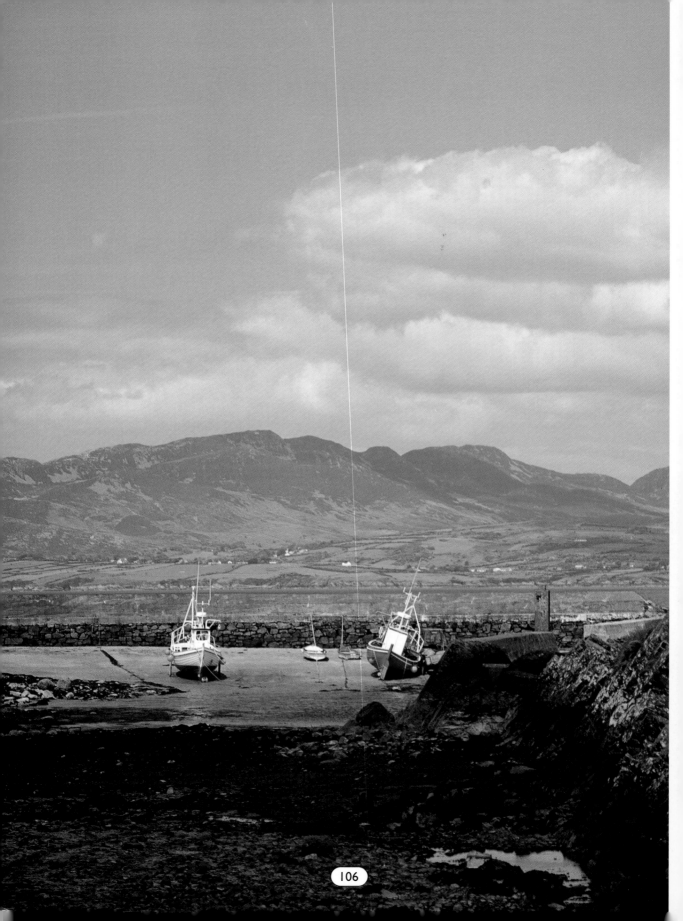

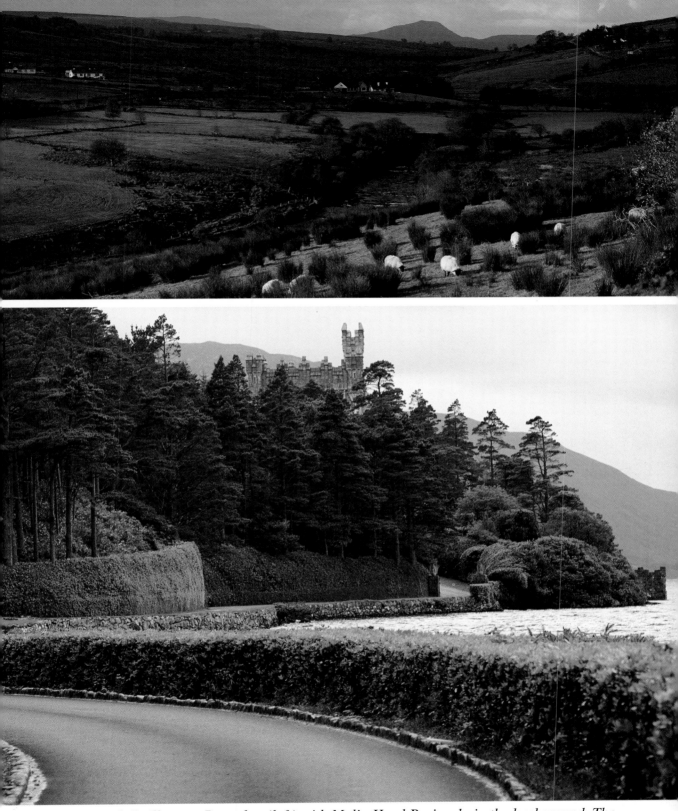

*An inlet of Lough Swilly near Portsalon (left) with Malin Head Peninsula in the background. The Glenties River (top) flows through a landscape of poor but picturesque land best suited to sheep farming. Glenveagh Castle (above) is seen here rising through the trees at the centre of the National Park.*

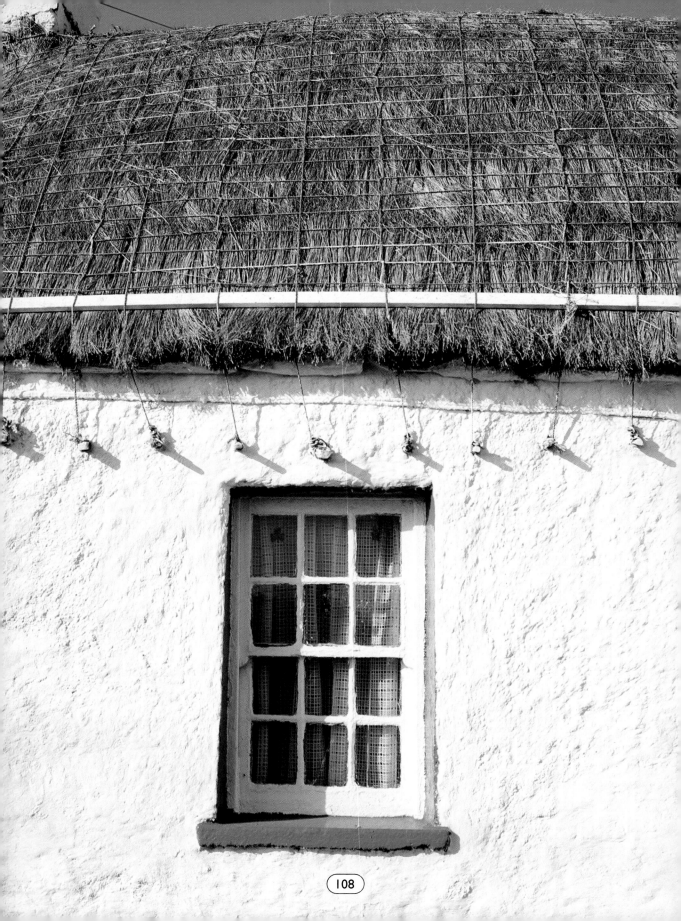

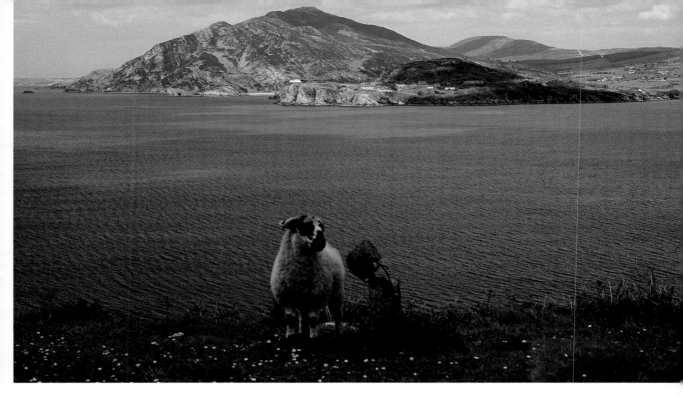

*Traditional Donegal thatching (opposite). Lough Swilly looking towards Dunree Head (above and below left). Cutaway bog near Dunlewy, with Errigal – the highest mountain in Donegal – in the background.*

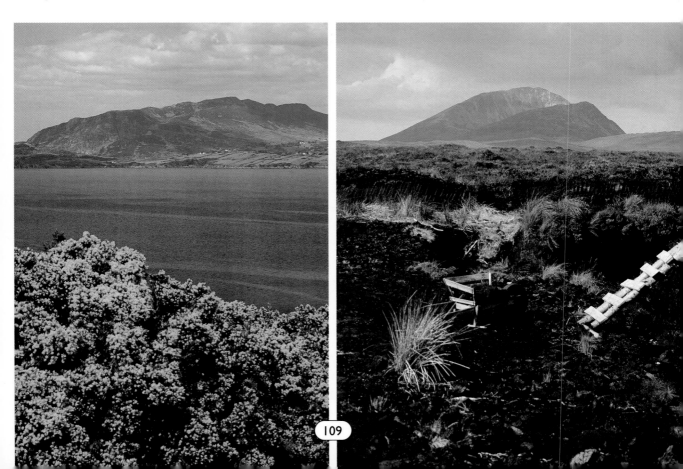

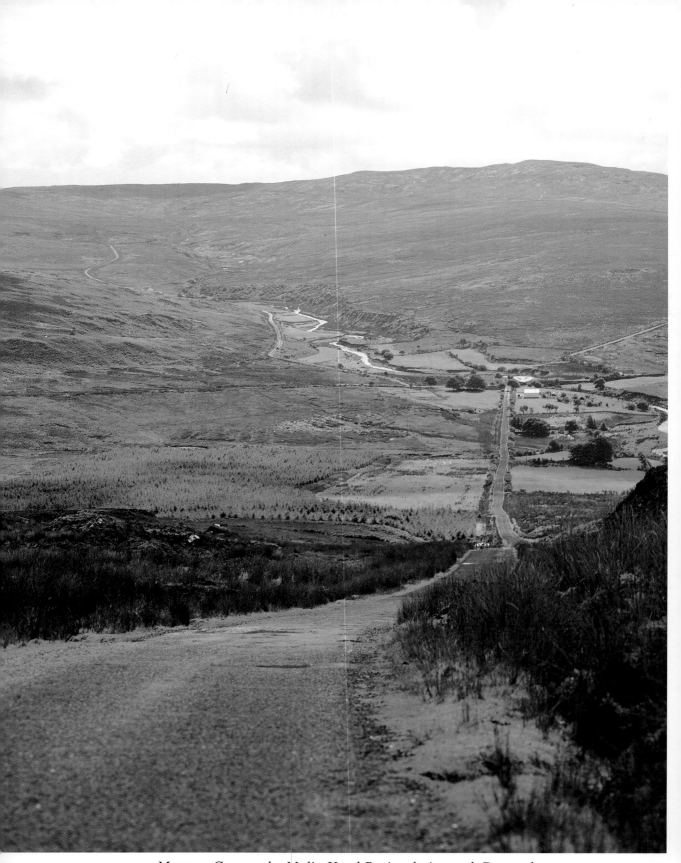

*Mamore Gap on the Malin Head Peninsula in north Donegal.*

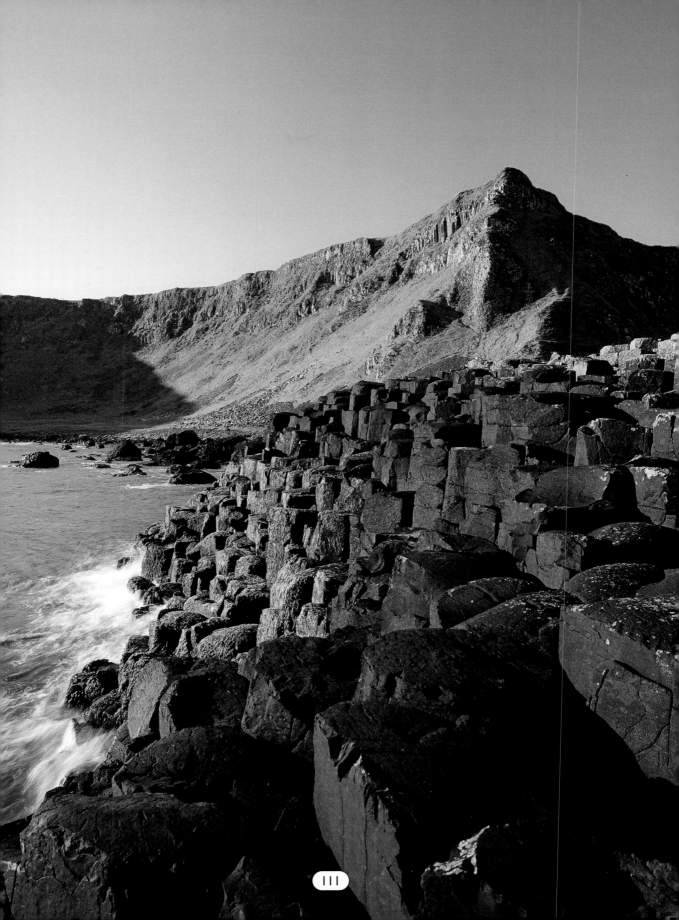

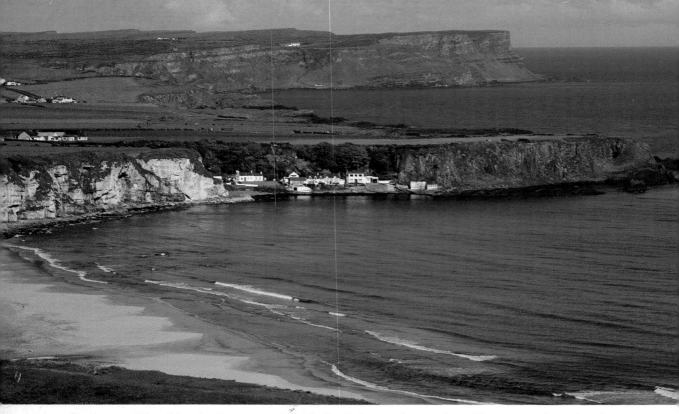

*Preceding page: The Giant's Causeway, which Dr Johnson famously said was worth seeing but not worth going to see. He was wrong. The whole north Antrim coast is an amazing succession of bays, inlets and sea stacks. White Park Bay (above) is a particularly beautiful beach, although unsafe for swimming. Dunluce Castle (below) stands precariously on the cliff edge near Portrush. The coast at Carrick-a-Rede looks across Rathlin Sound to Rathlin Island offshore (opposite).*

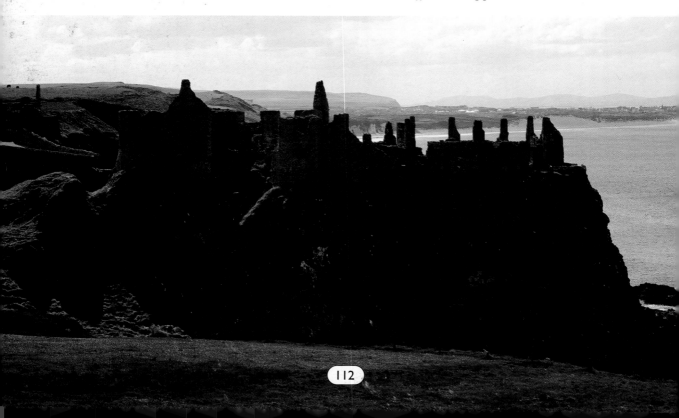

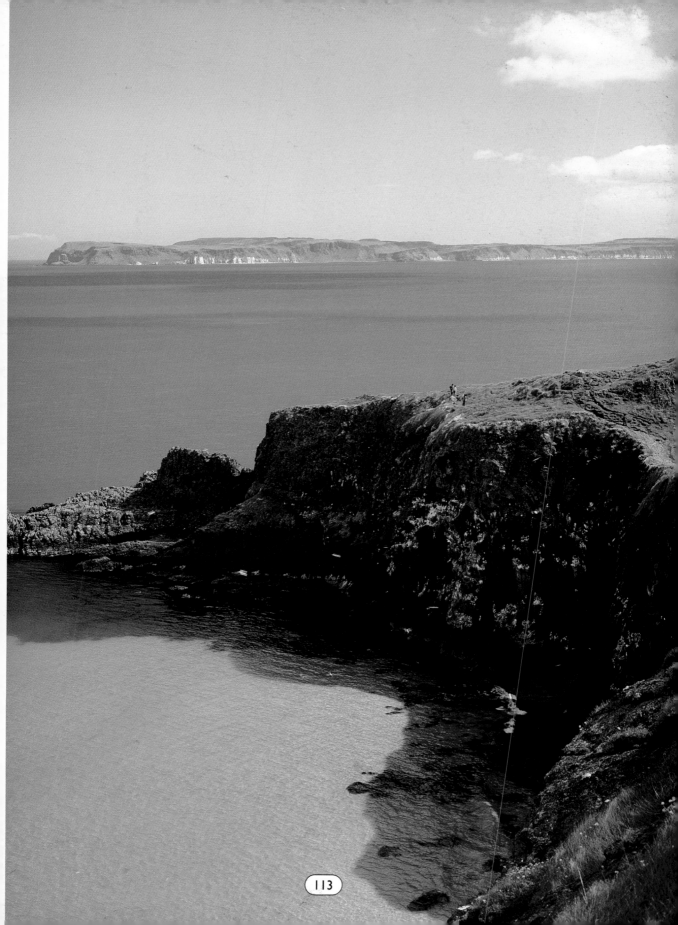

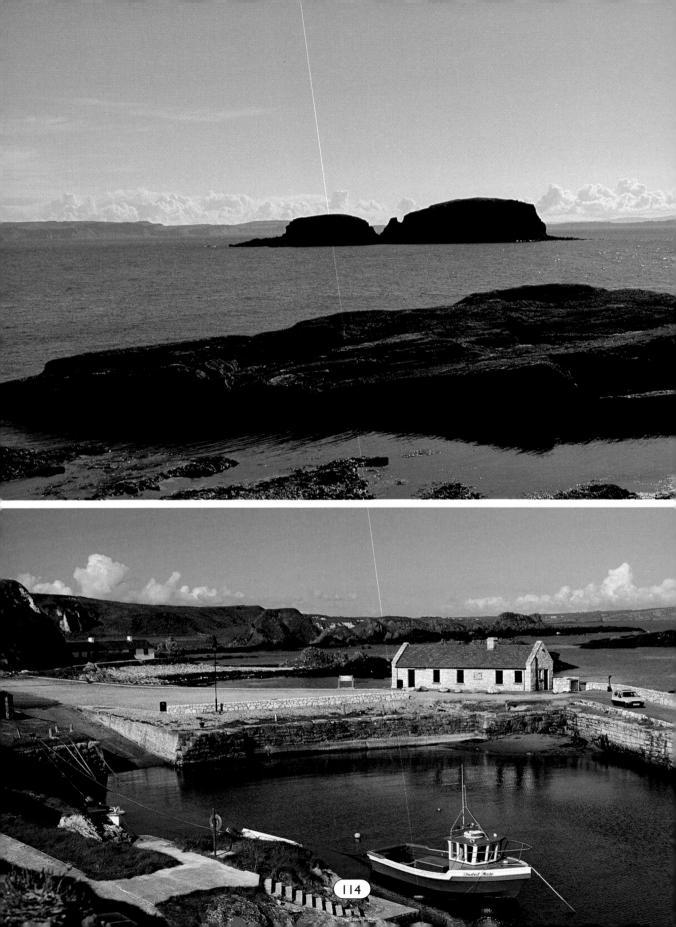

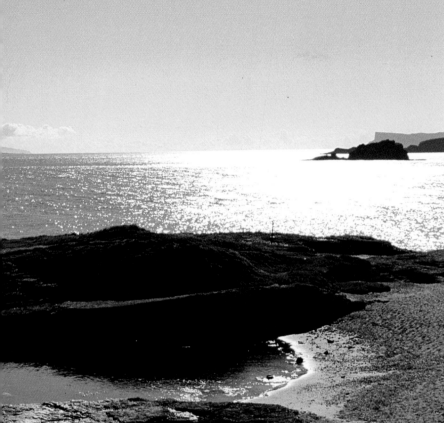

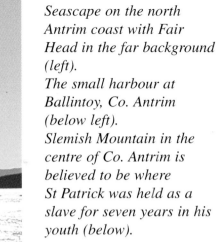

*Seascape on the north
Antrim coast with Fair
Head in the far background
(left).
The small harbour at
Ballintoy, Co. Antrim
(below left).
Slemish Mountain in the
centre of Co. Antrim is
believed to be where
St Patrick was held as a
slave for seven years in his
youth (below).*

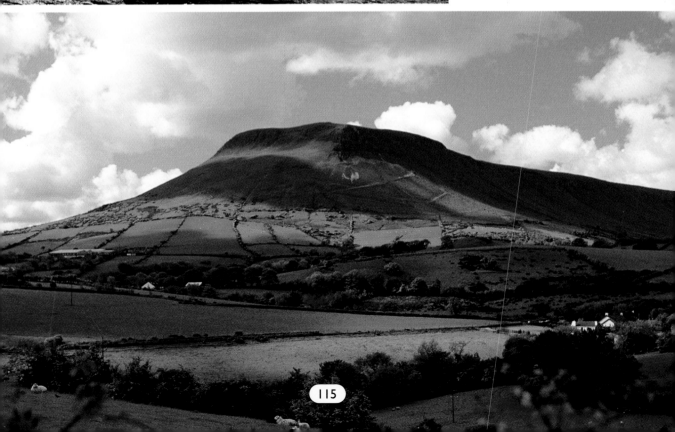

*Glenariff Forest Park in the Glens of Antrim (above).*
*On the shores of Lough Neagh, the largest lake in Ireland (opposite top).*
*Torr Head on the north-east coast of Antrim (right). Those mountains in the background are in Scotland!*

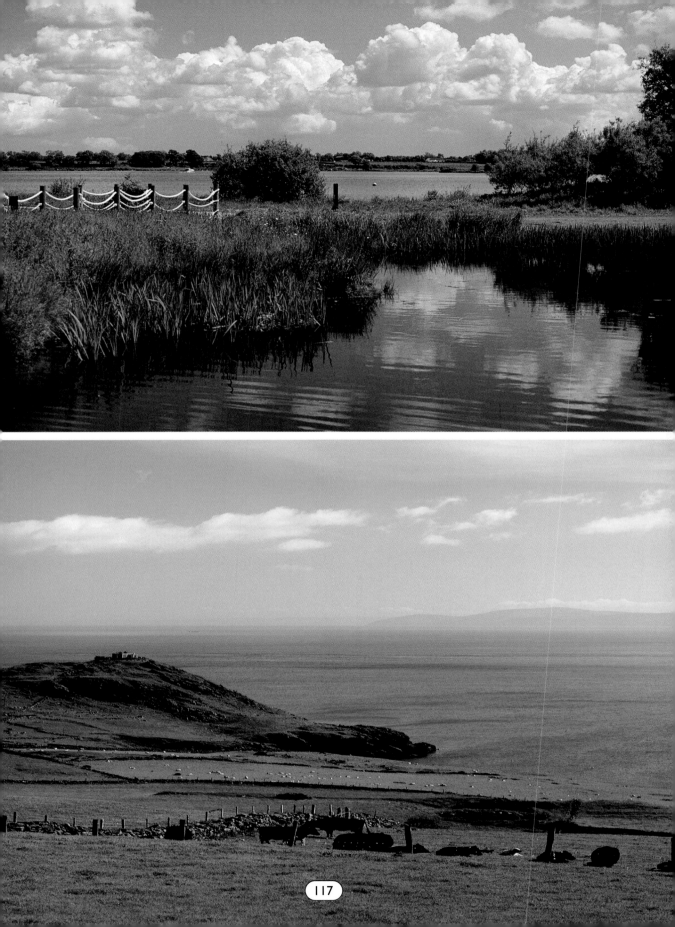

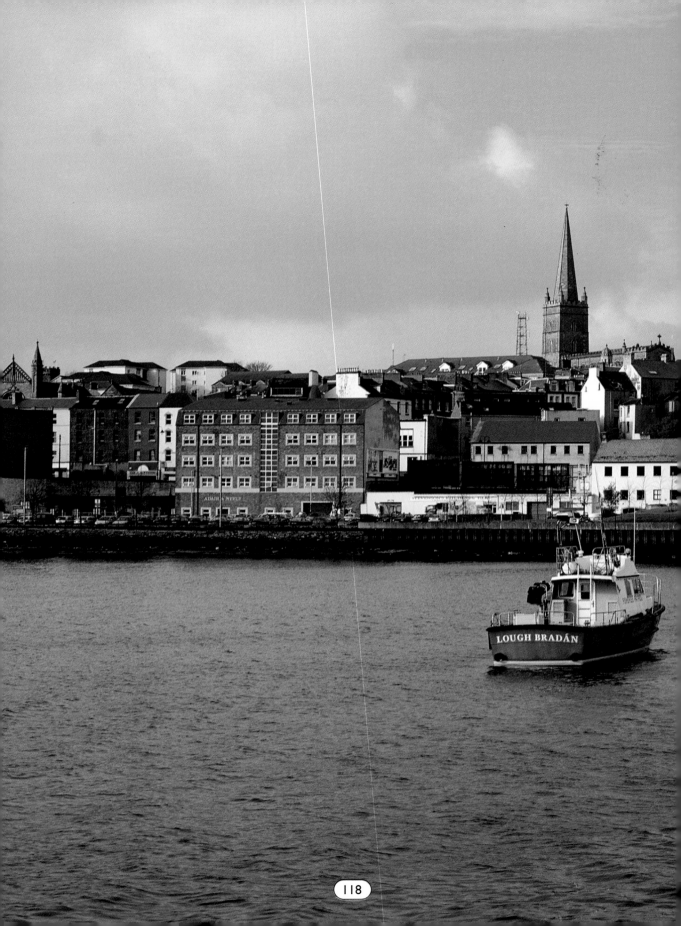

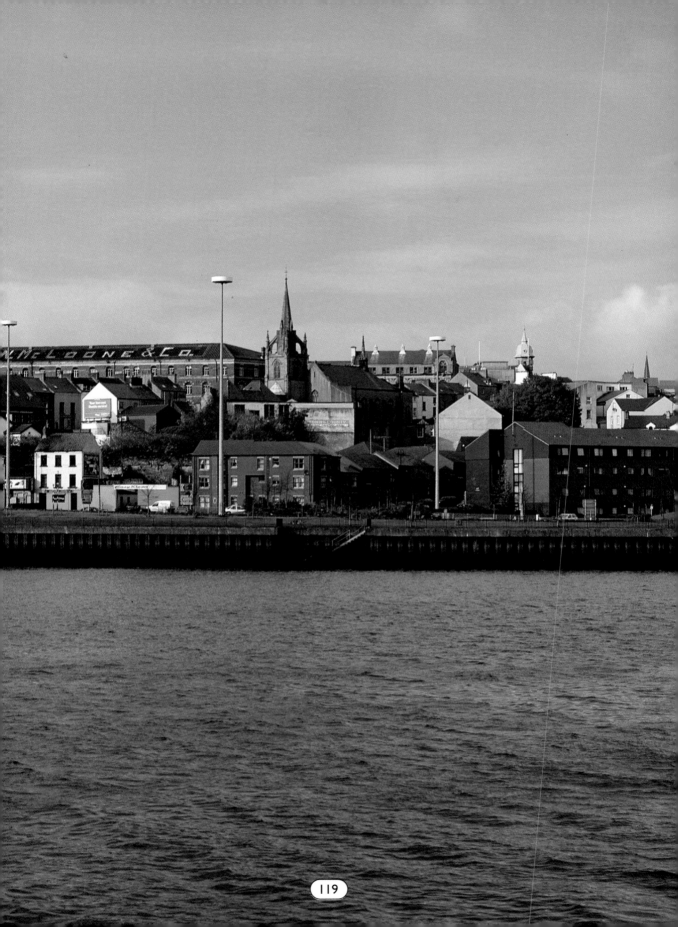

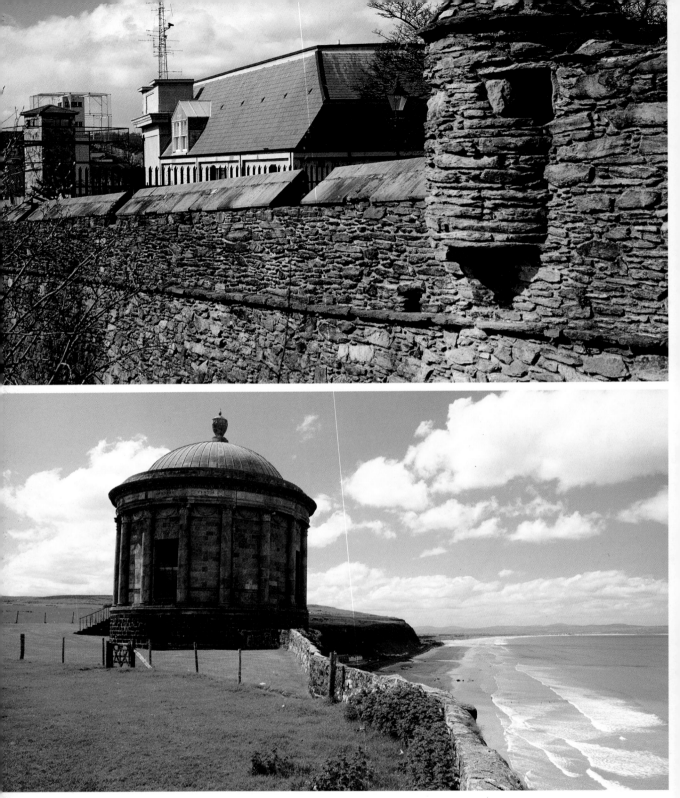

*Preceding pages: A view of Derry from the River Foyle. The Walls of Derry (top) are still in good repair and enclose the historic plantation city. The Mussenden Temple (above) on the north Derry coastline is a classical folly built by Lord Hervey, the eccentric bishop of Derry in the eighteenth century. The fine Guildhall in the city contains this stained-glass memorial to the founders of the modern city (right).*

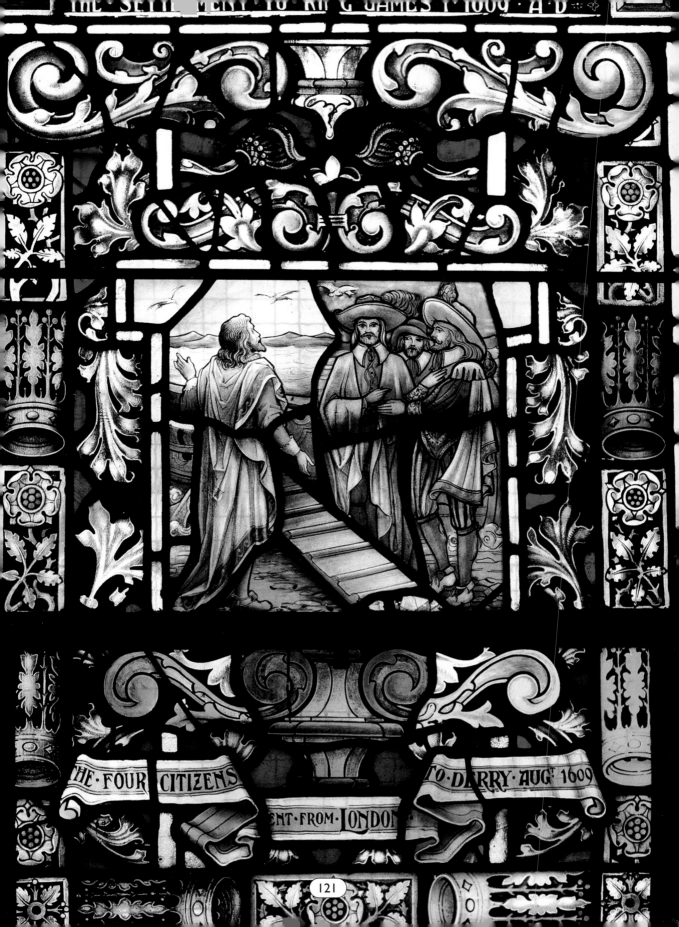

THE·FOUR·CITIZENS ... ENT·FROM·LONDON ... TO·DERRY·AUG$^t$ 1609

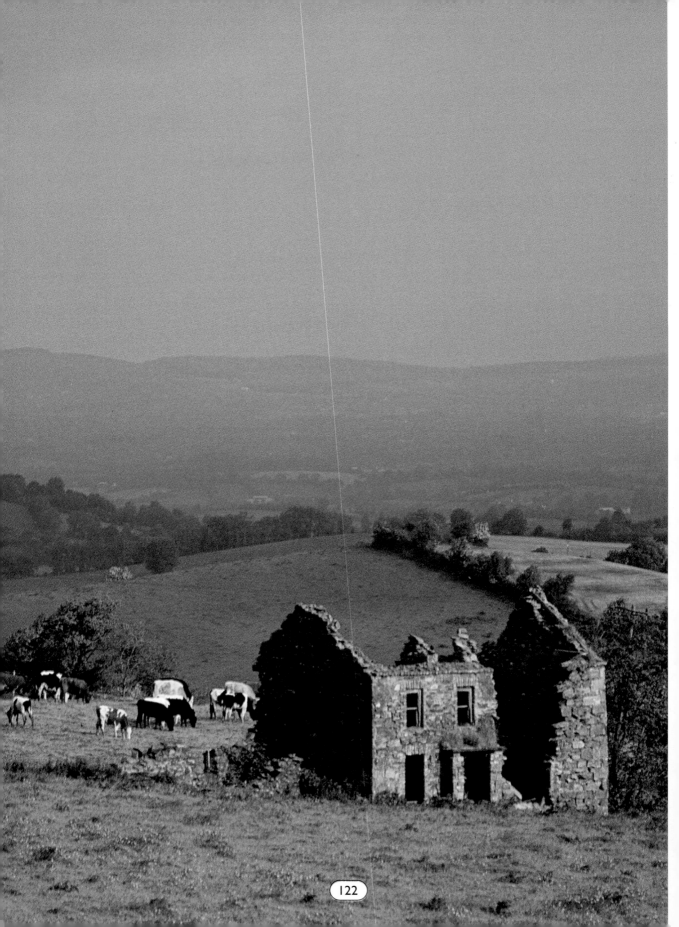

Drumlin country in Co. Monaghan (opposite). Drumlins – low, rolling hills – are a feature of the south Ulster landscape.
A roadside folly in Co. Tyrone (above).
A rushing stream in Gortin Forest Park, Co. Tyrone (below).

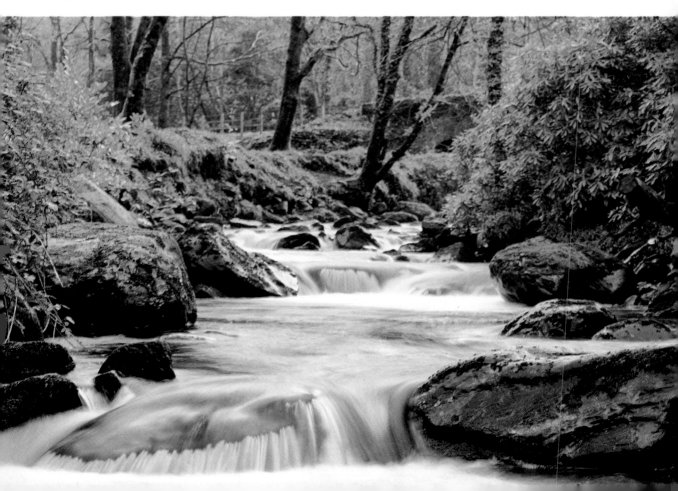

*Co. Down runs from the Mourne Mountain country of the south (right) to the pleasant shores of Dundrum Bay (below left) and the flatter, more fertile northern part of the county near Belfast where Rowallane Gardens (below far right) may be found. The contrasts that are never far apart in Irish landscape are in evidence here as well, however. The dolmen near Ballinahinch, in the middle of the county (below centre), is a testimony to the ancient settlement of this part of the country.*

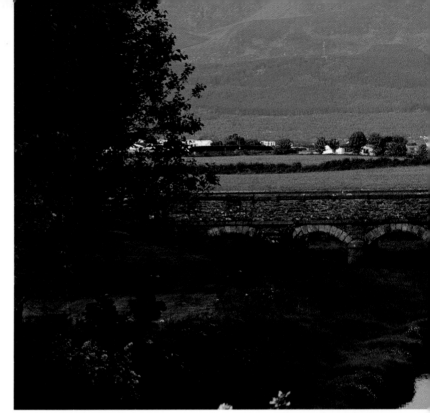

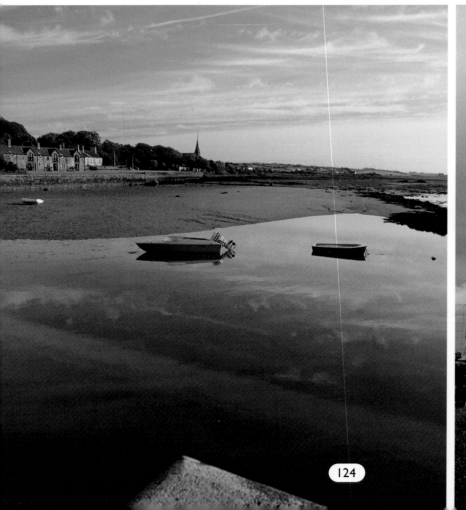

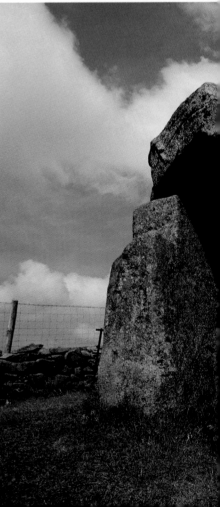

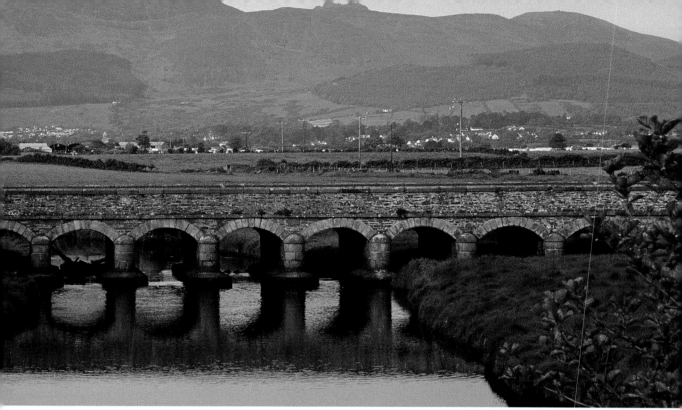

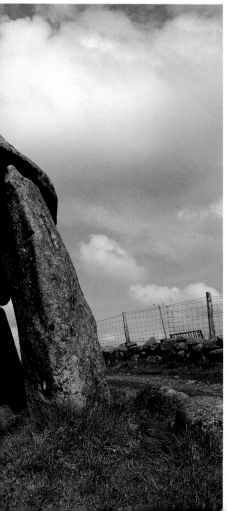

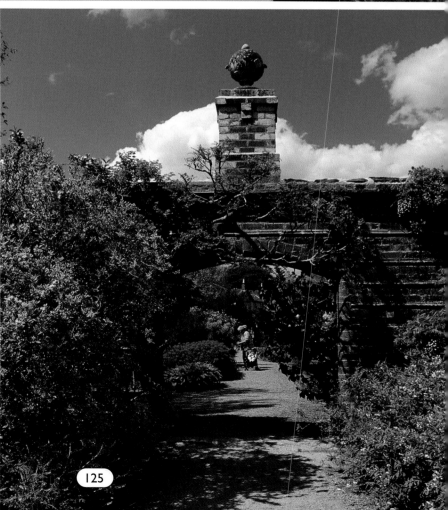

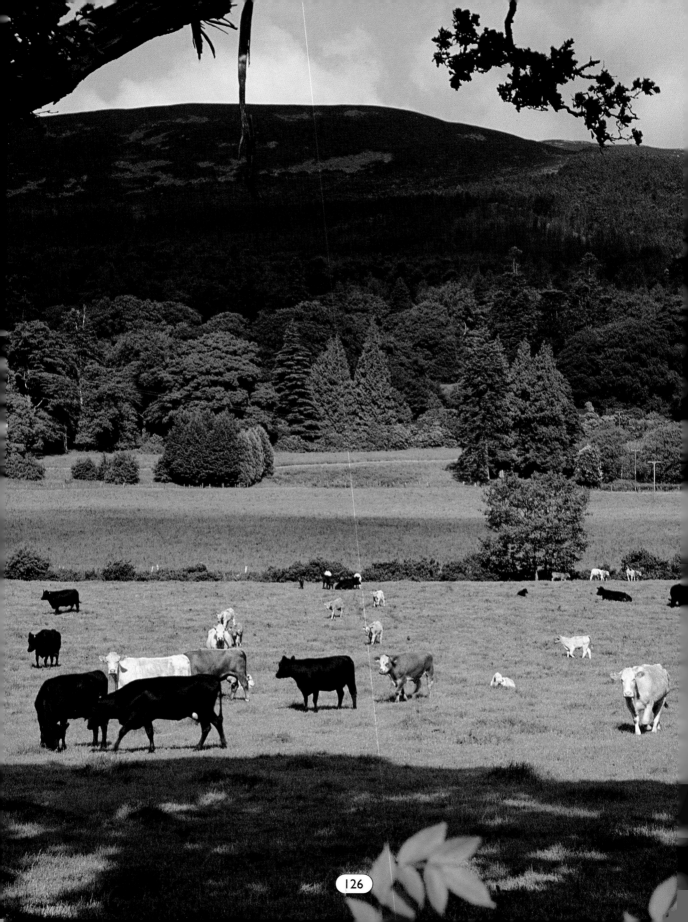

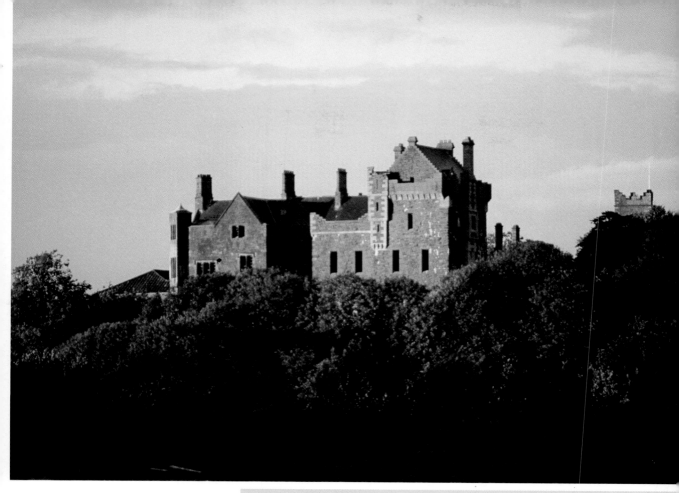

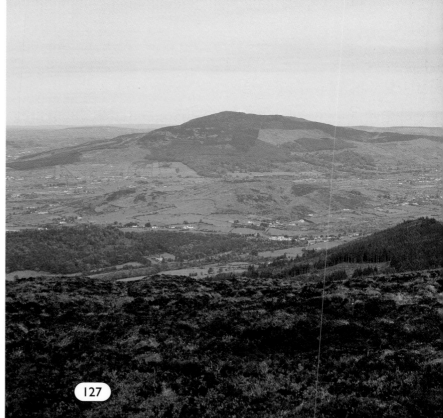

*View of Slieve Gullion, Co. Armagh (left). Tandragee Castle (top). Slieve Gullion, seen from Windy Gap (right).*

*Gosford Forest Park, Co. Armagh.*